Guy Anderson

Guy Anderson

Essay by Bruce Guenther

Francine Seders Gallery
Distributed by
University of Washington Press
Seattle and London

Published by Francine Seders Gallery
6701 Greenwood N.
Seattle, Washington 98103

Distributed by
University of Washington Press
P.O. Box C-50096
Seattle, Washington 98145

Edited by Glory Jones
Designed and produced by Ed Marquand Book Design
Printed and bound in Hong Kong

Photo credits: All photos by Chris Eden, except plate 4,
Mike Fischer; plate 14, Ed Marquand; plate 45, courtesy
Museum of Art, Washington State University, Pullman.
Photo of Anderson, p. 106, Robert Sarkis.

Cover: *Fiery Night*, 1985 (plate 61)
Back cover: *Winter Seed*, 1985 (plate 62)

ISBN 0–295–96418–9 (cloth)
ISBN 0–295–96419–7 (paper)

To pull ourselves
unsanctified from
the mouth of the
milken sea

——Guy Anderson

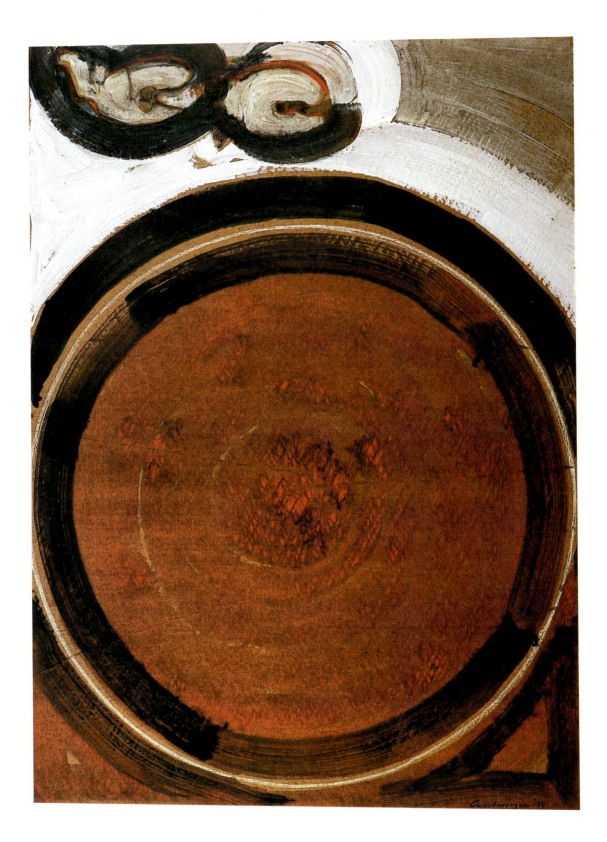

1. *Conjugal Vajra*, 1979

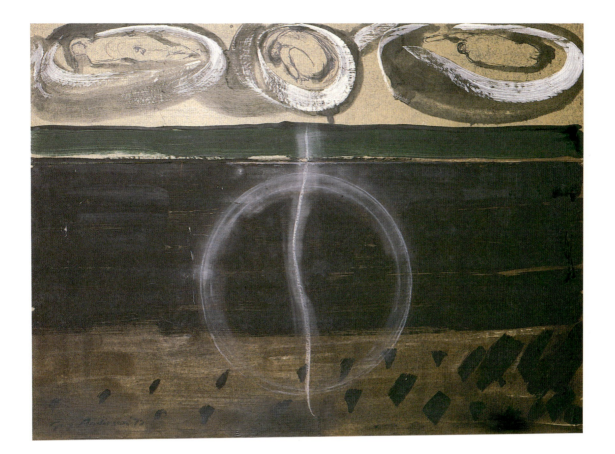

2. *Eclipse of the Moon*, 1972

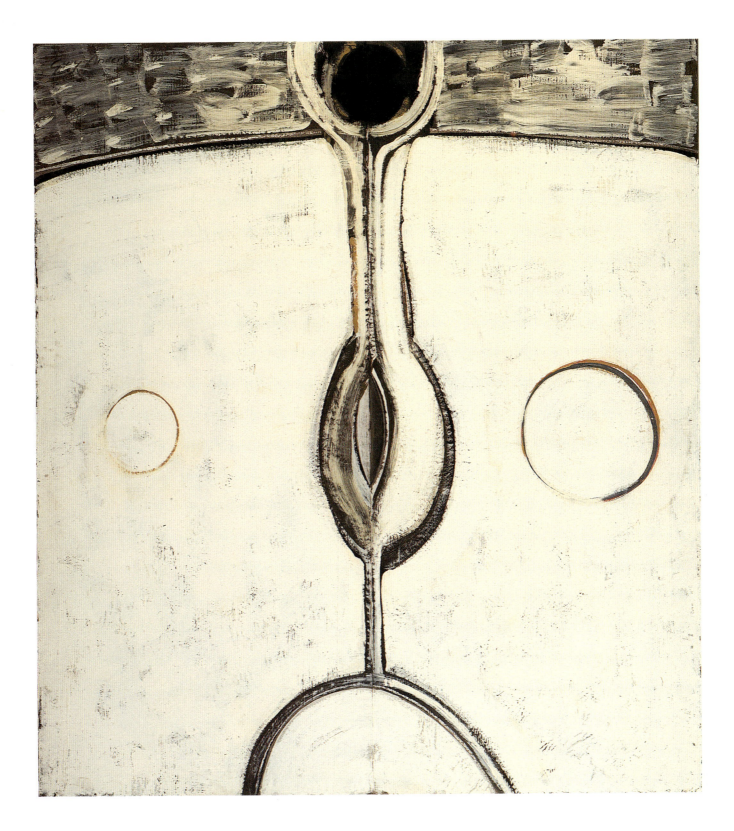

3. *Purusa*, 1972

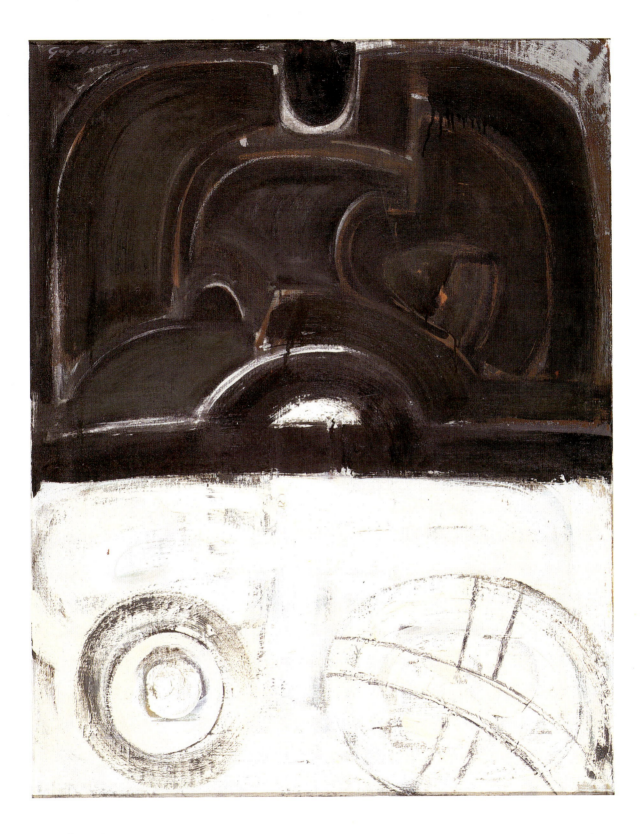

4. *Northern Birth*, 1967

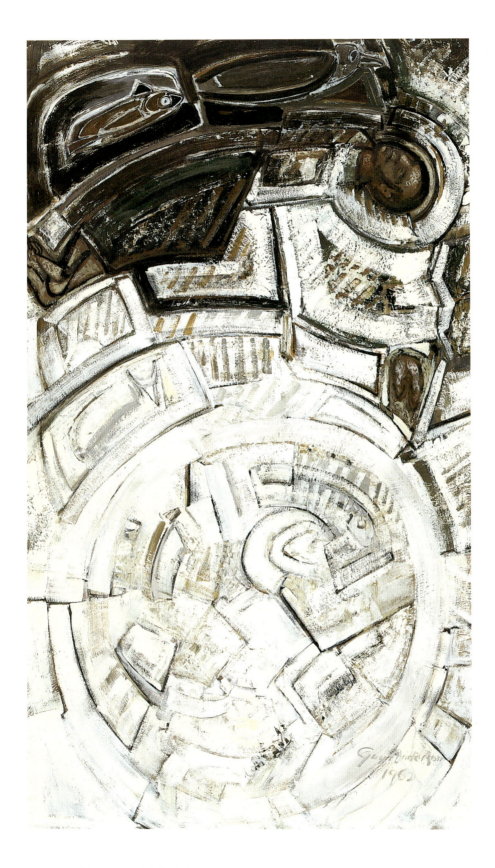

5. *Dream of the Language Wheel,* 1962

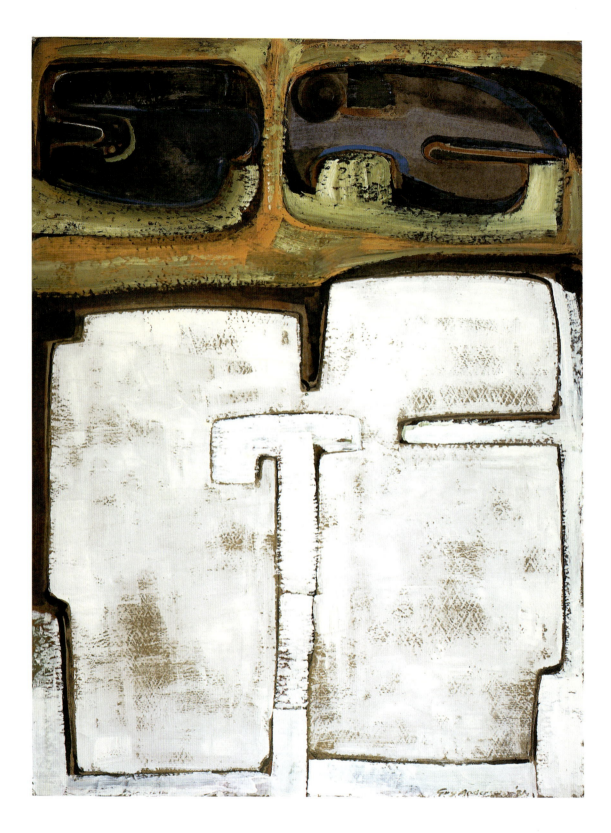

6. *Quiet Winter*, 1980–81

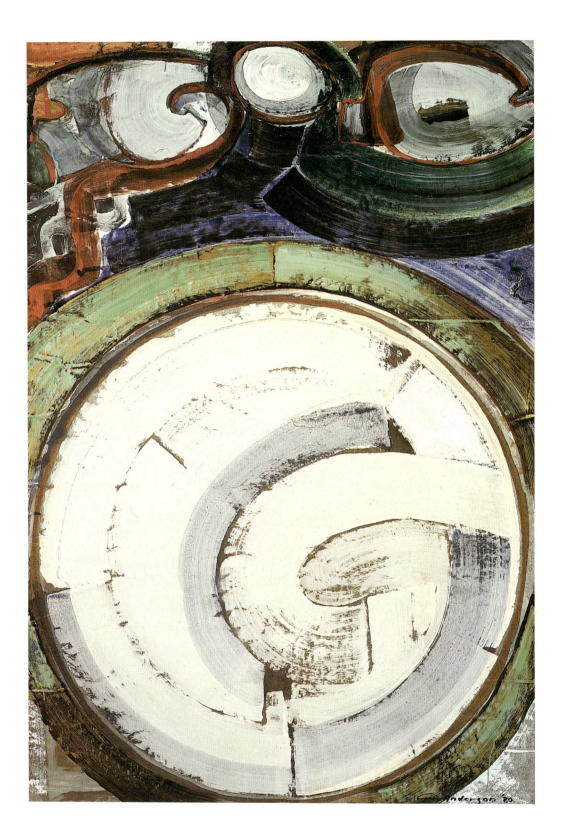

7. *Triumph of the Egg*, 1980

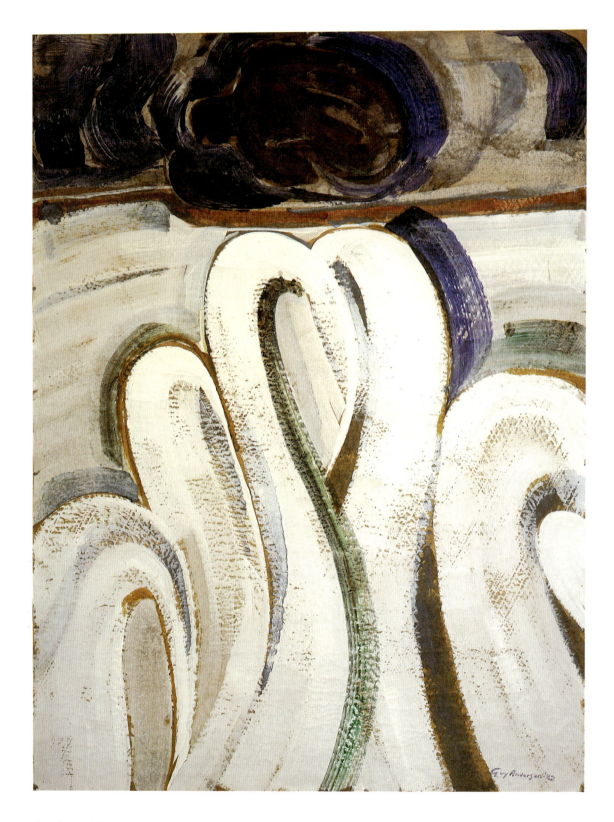

8. *Autumnal Equinox*, 1982

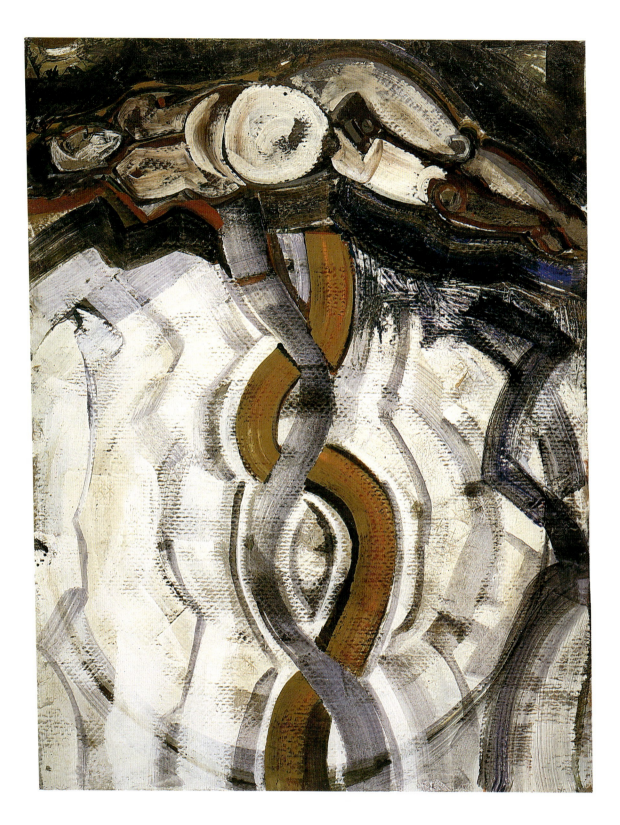

9. *The Birth of Prometheus*, 1984–85

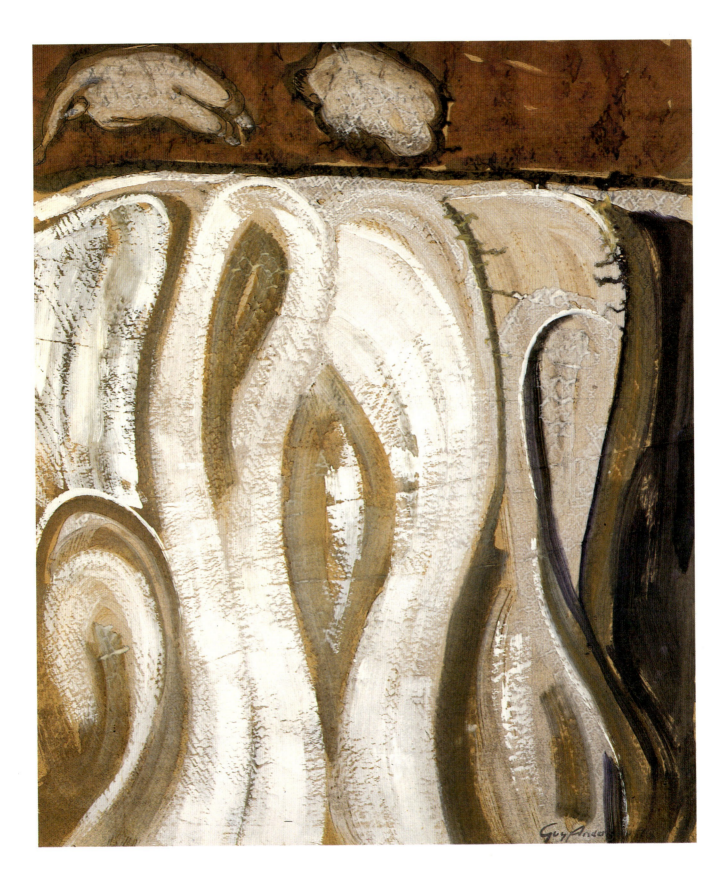

10. *Over the Persian Sea*, 1976

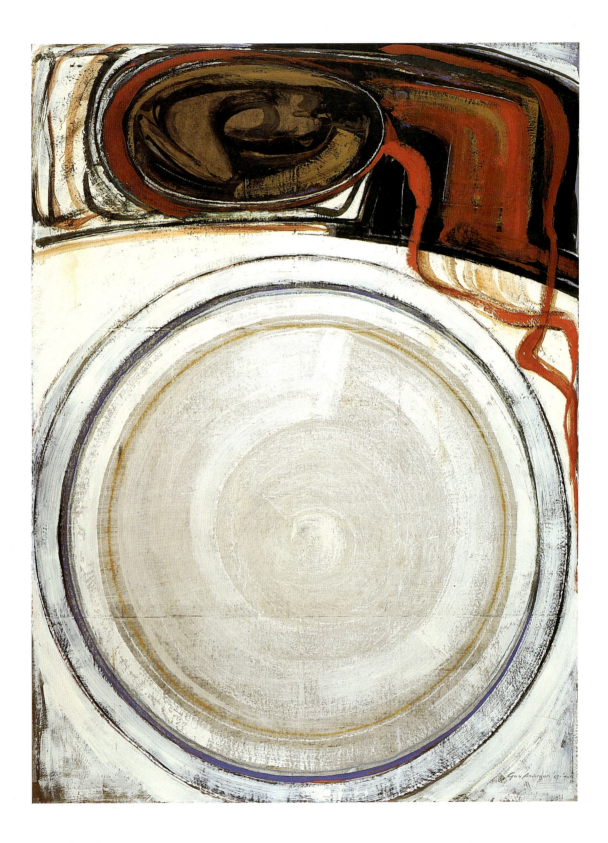

11. *Birth of Adam*, 1969–70

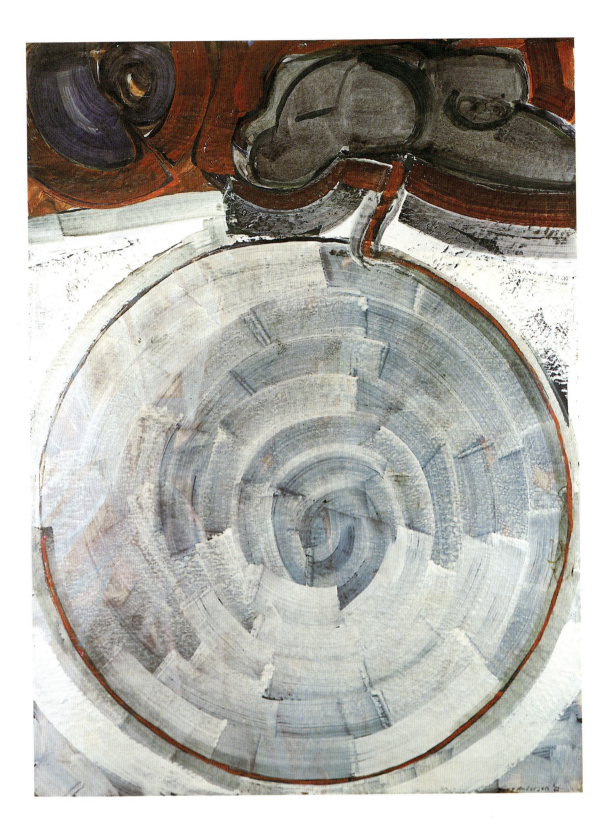

12. *Prometheus,* 1982

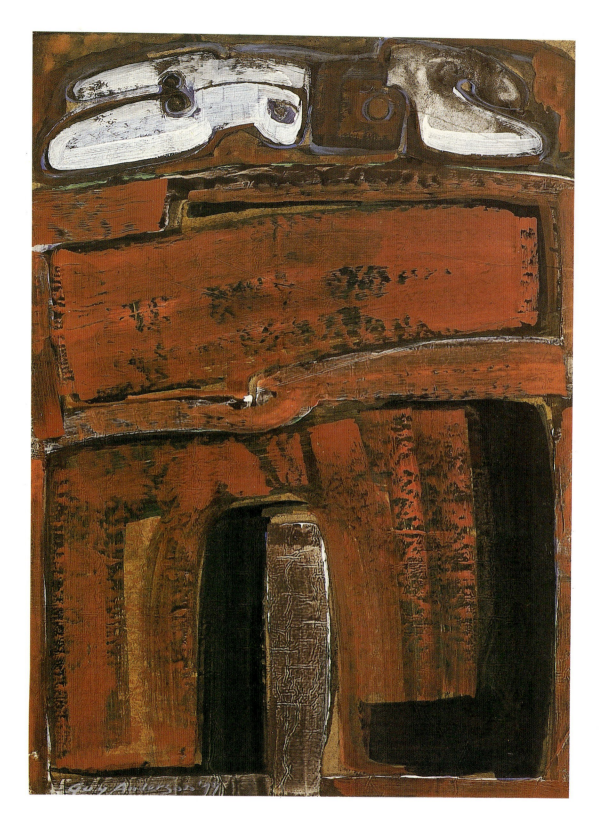

13. *Seed in the Stream*, 1979

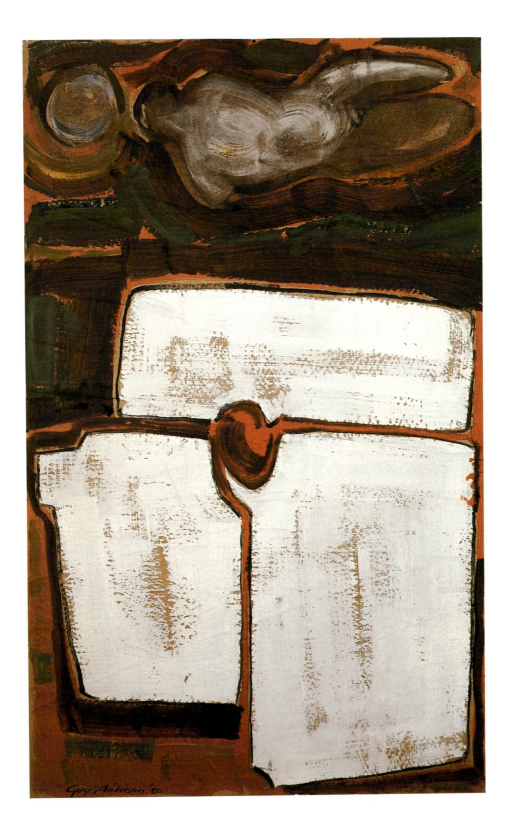

14. *Egg and Moon*, 1980

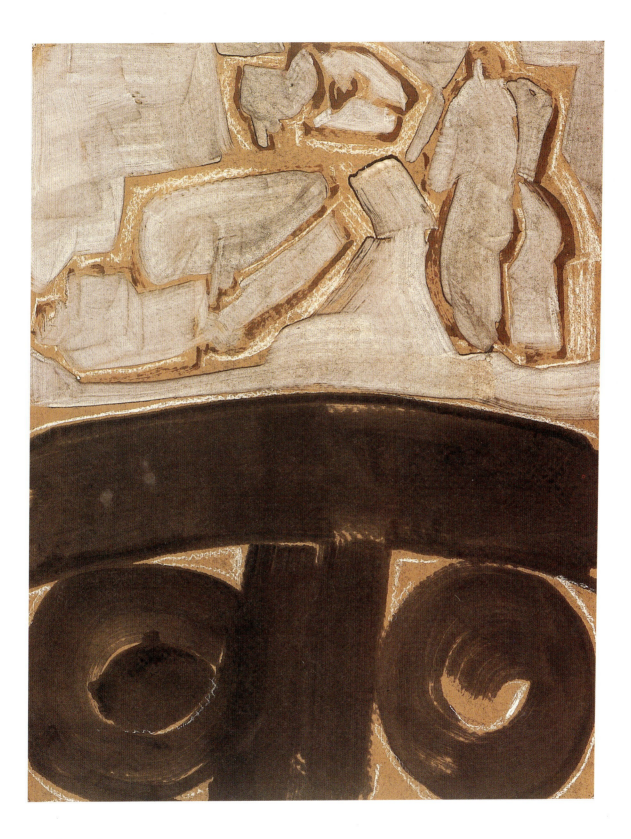

15. *The Heavy Decision*, 1986

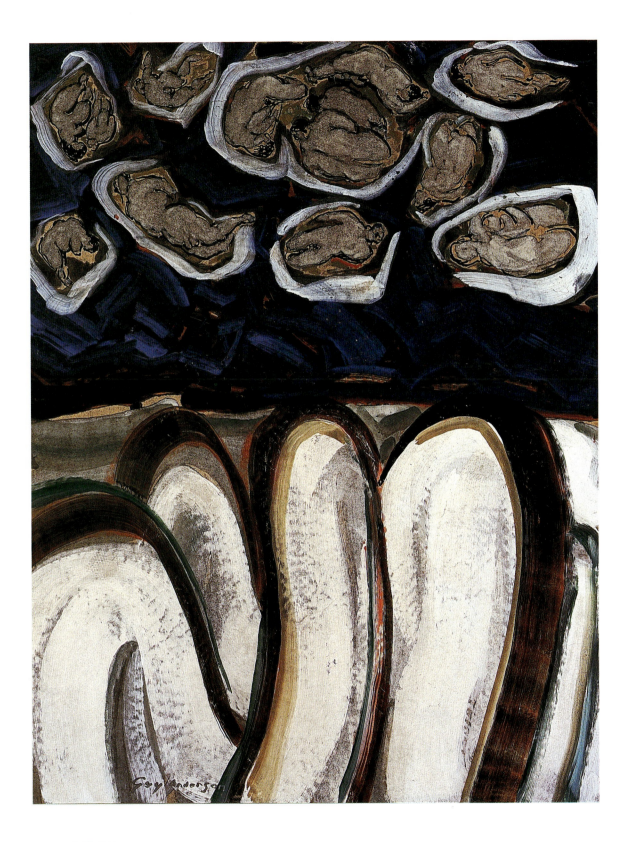

16. *Nightfall*, 1984

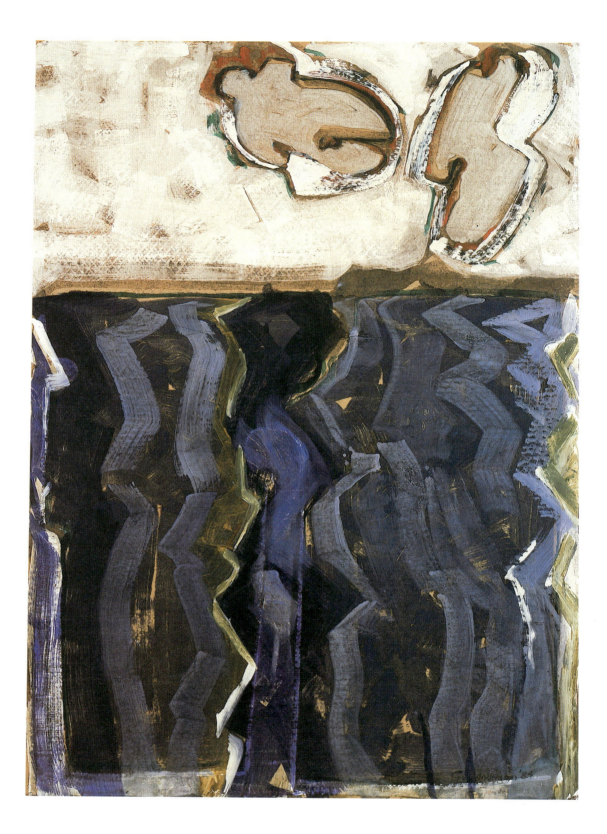

17. *Persian Gulf*, 1984

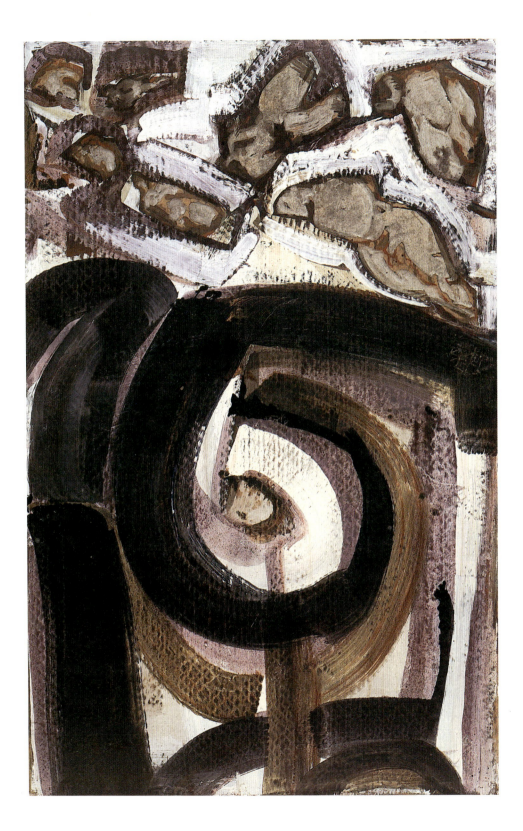

18. *Around the Center*, 1986

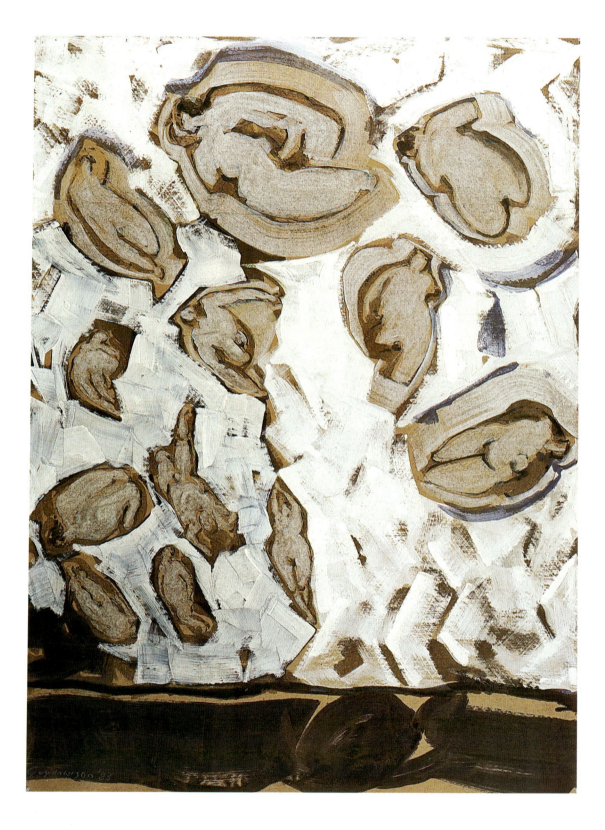

19.　*Torsos in a White Sea*, 1983

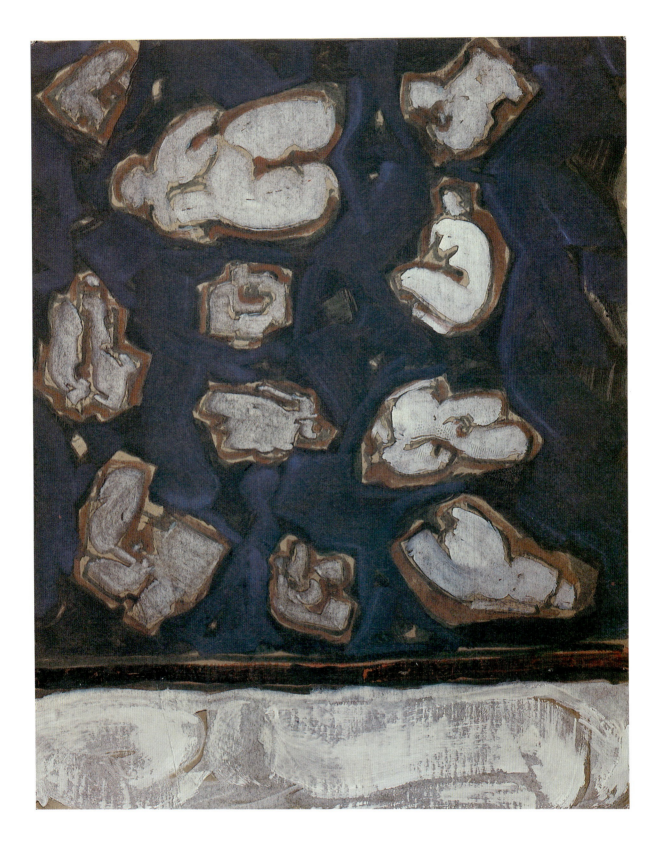

20. *Sky Full of Torsos*, 1983

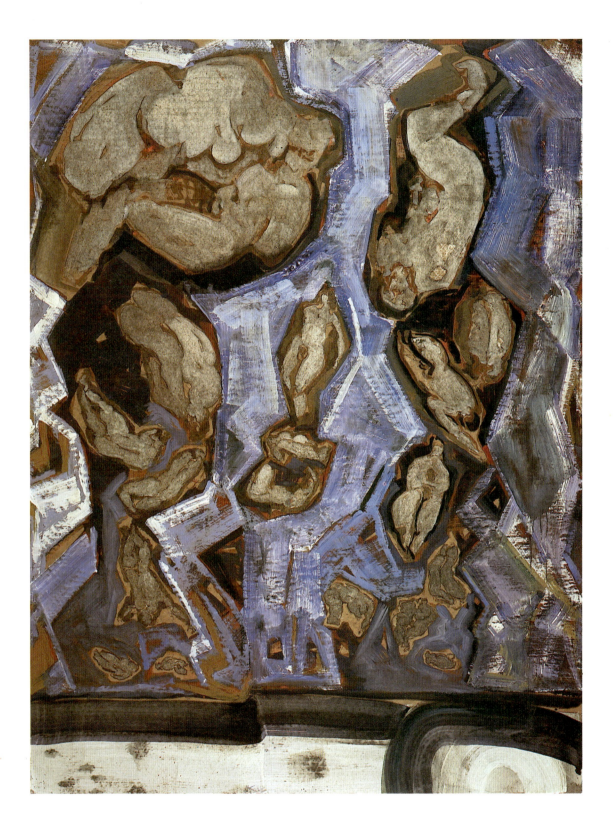

21. *Ascent and Fall in the Morning*, 1986

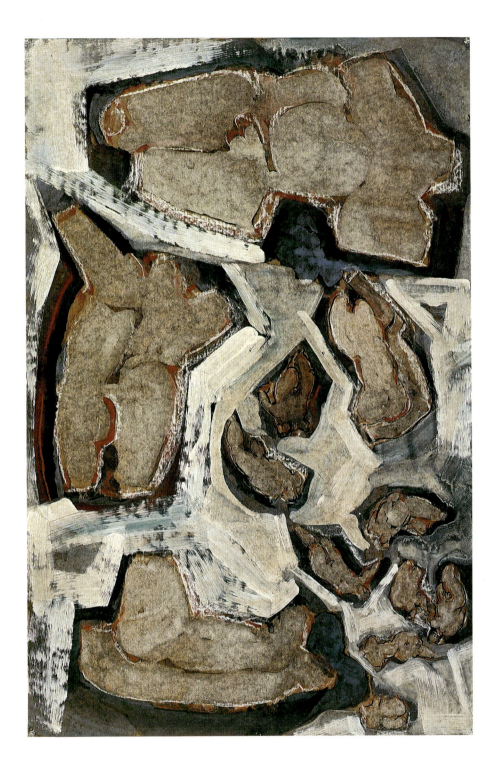

22. *Day Fragments*, 1985

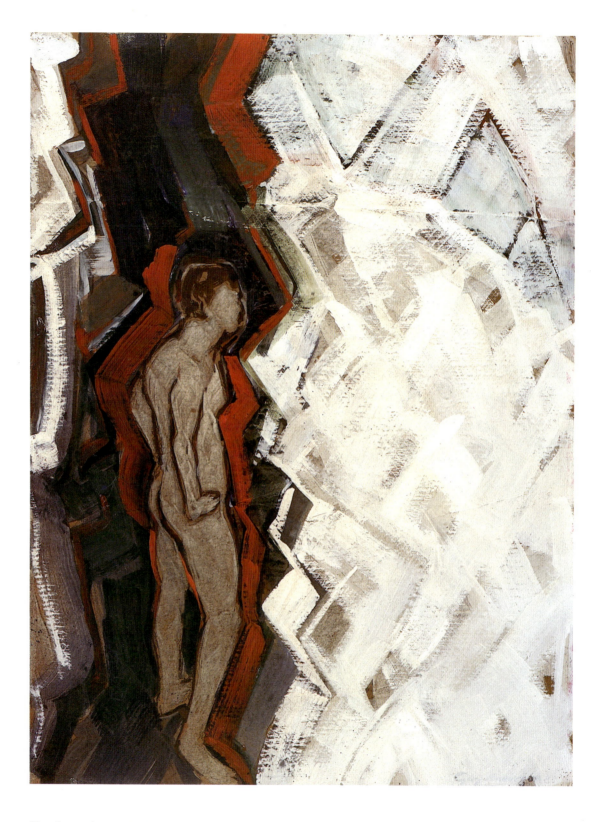

23. *Summer Swimmer*, 1985

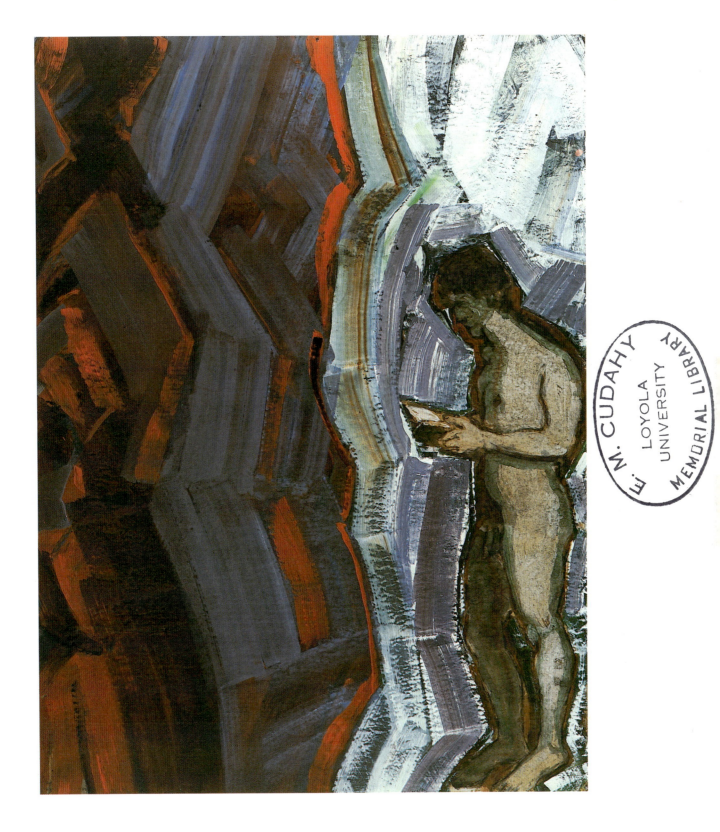

24. *Reading in the Rocks*, 1985

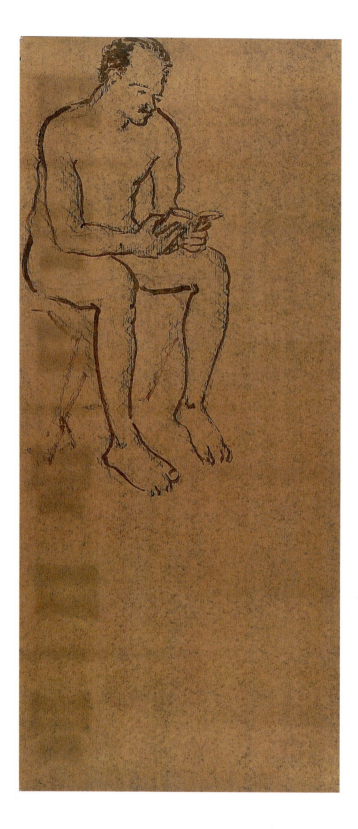

25. *Untitled*, 1985

26. *Untitled*, 1985

27. *Swimmers Resting*, 1983

28. *Reading Out of Doors*, 1984

29. *Standing Figure*, 1984

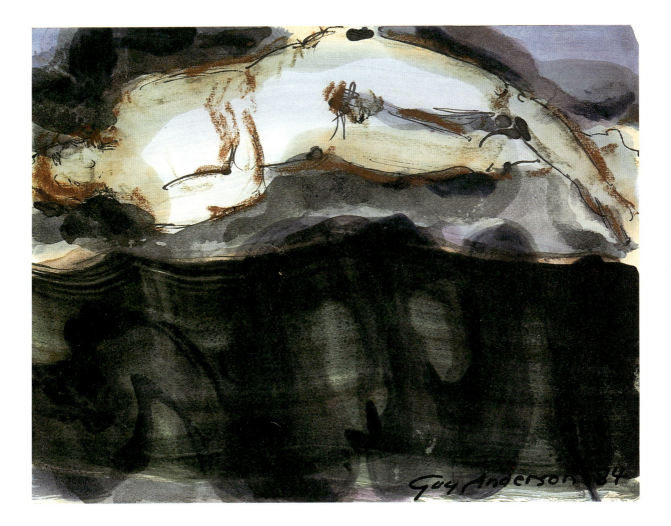

30. *Floating Figure*, 1984

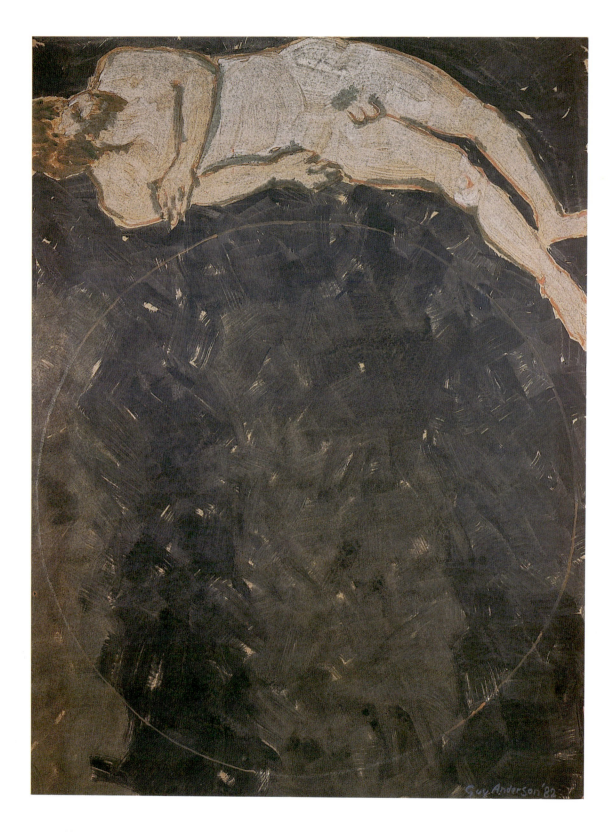

31. *Galileo's Dream*, 1982

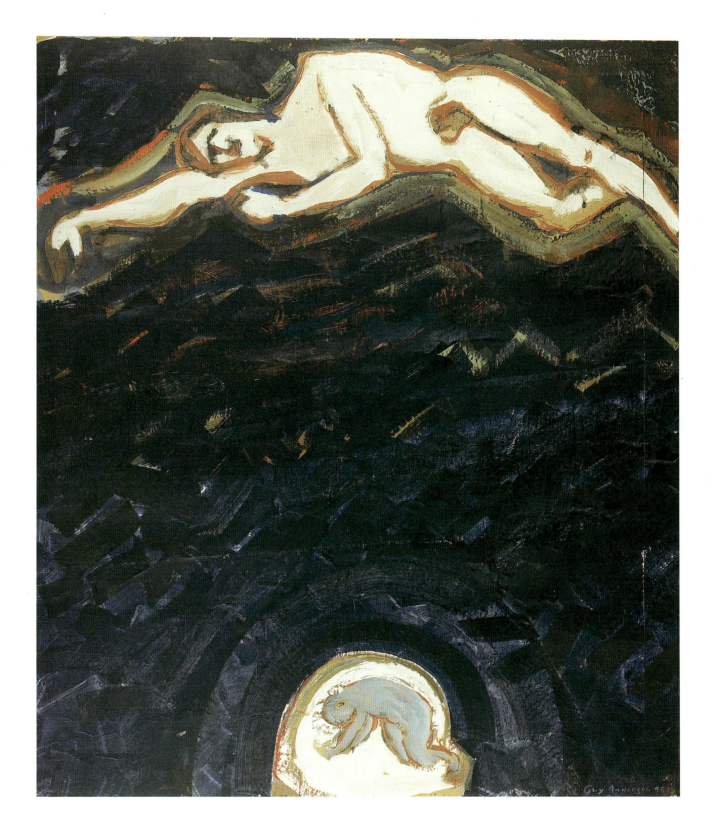

32. *Father and Son*, 1974

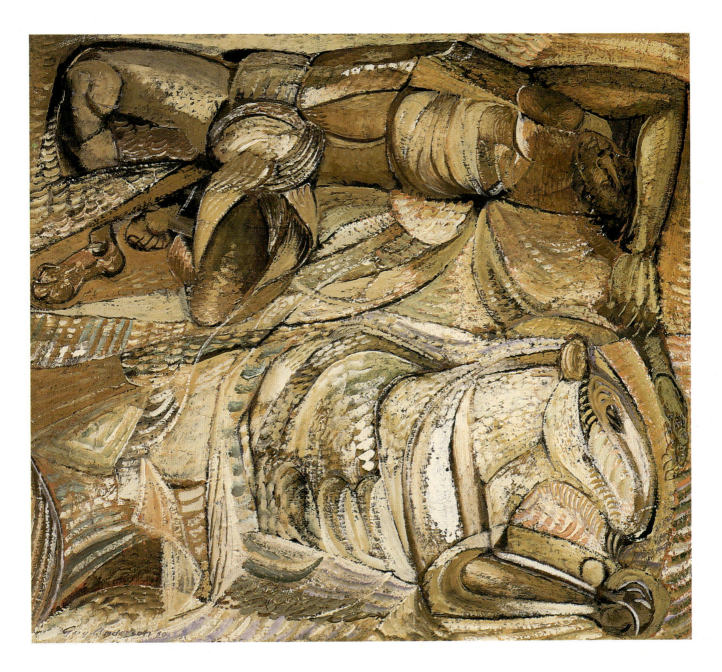

33. *Prometheus*, 1950

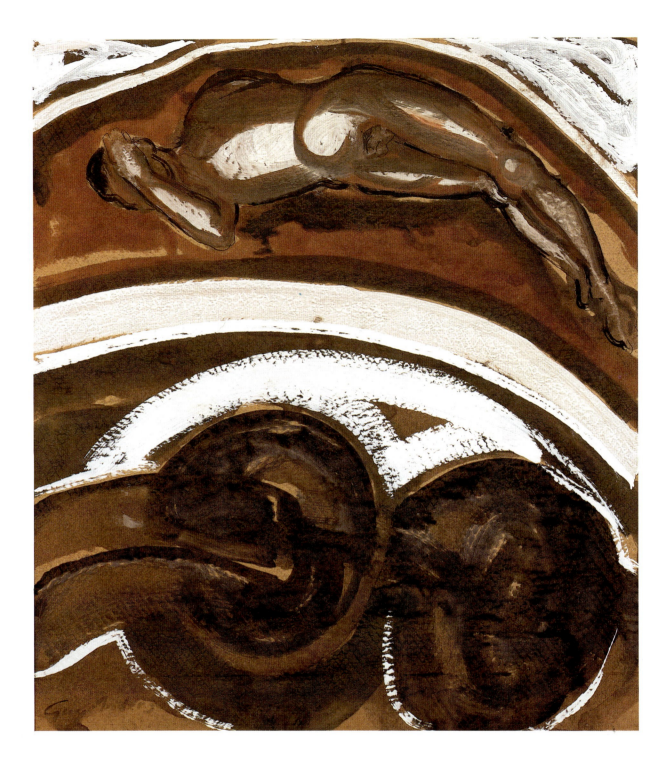

34. *Encounter with Kali*, 1975

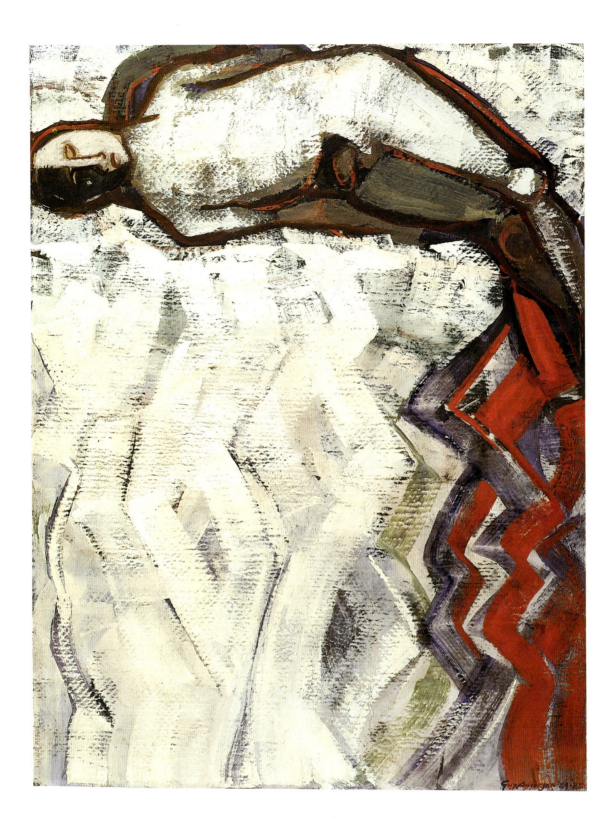

35. *Figure over the Sea,* 1984–85

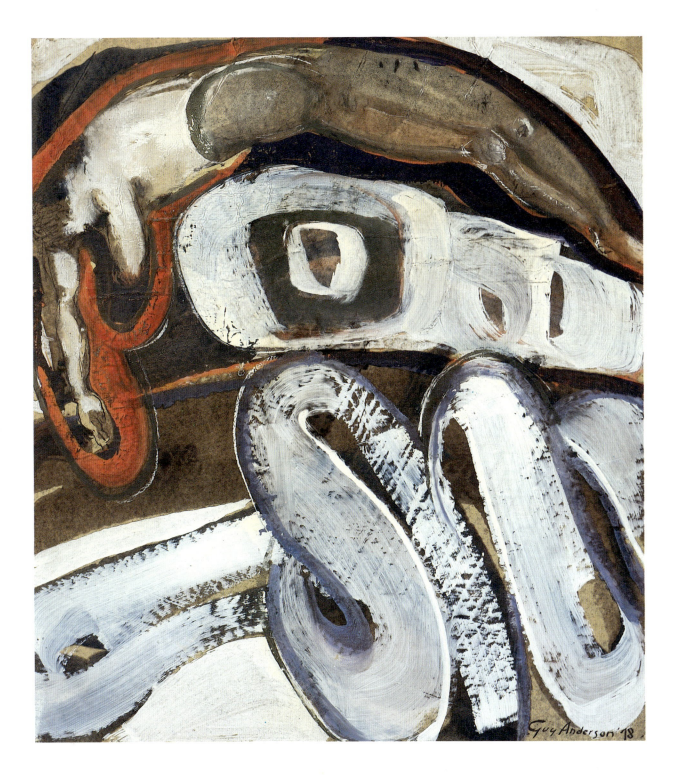

36. *Laocoön*, 1978

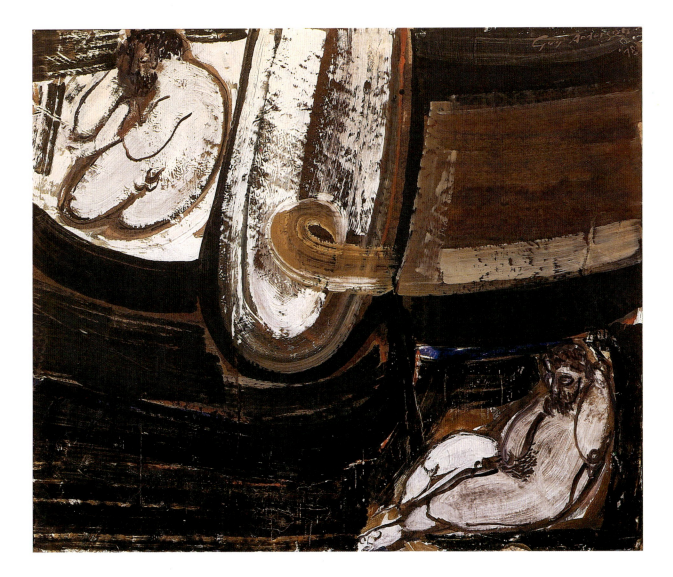

37. *Persian Philosophers*, 1978

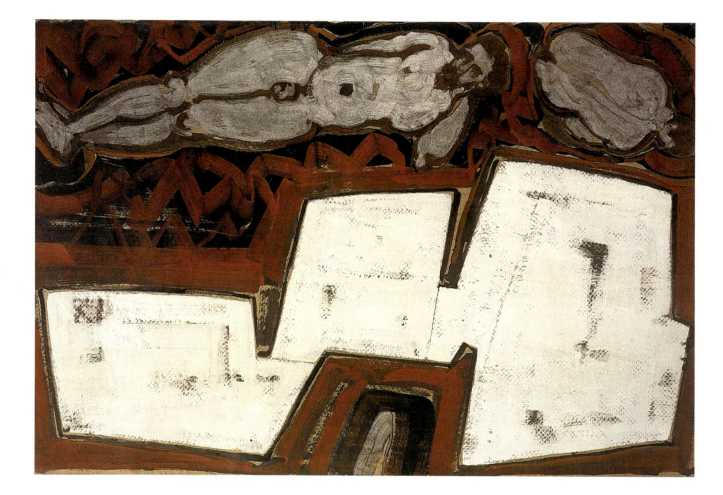

38. *Icarus*, 1985

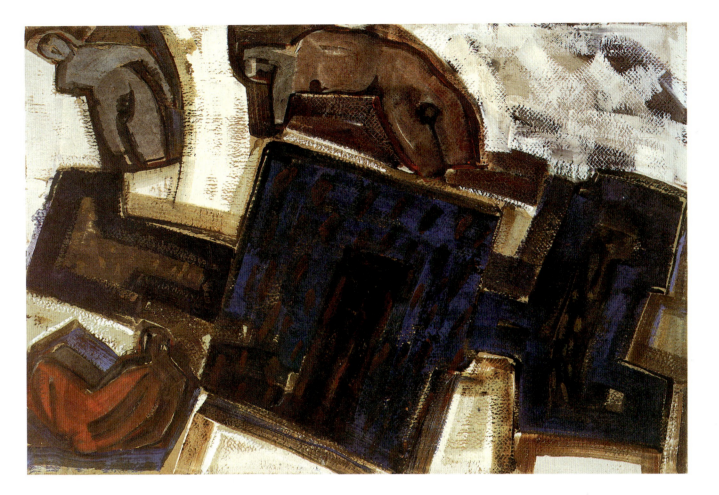

39. *Autumnal Equinox (Sisyphus)*, 1984

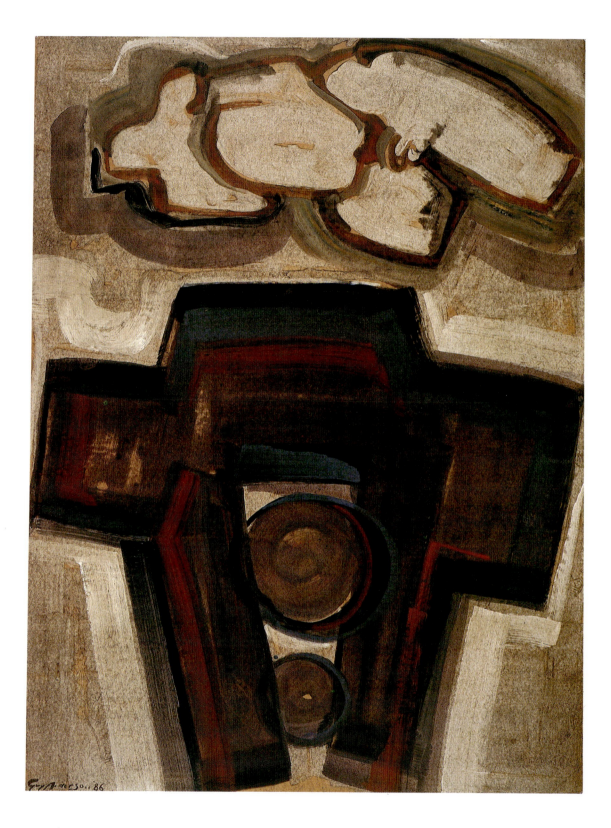

40. *The Exacting Moment*, 1986

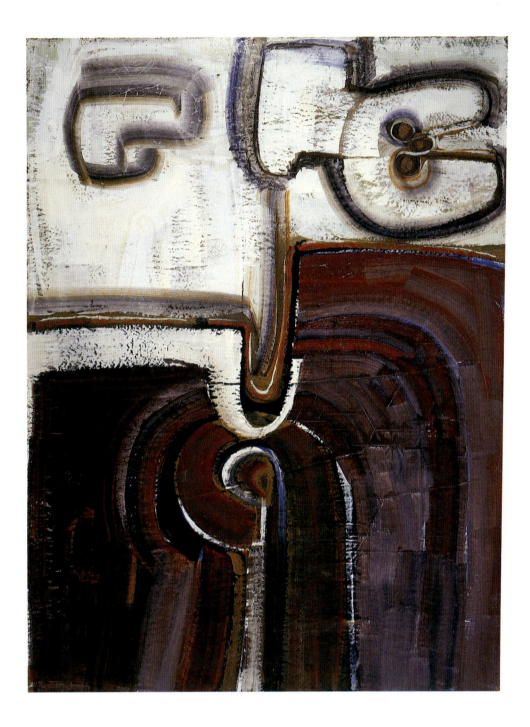

41. *Persian Dilemma*, 1986

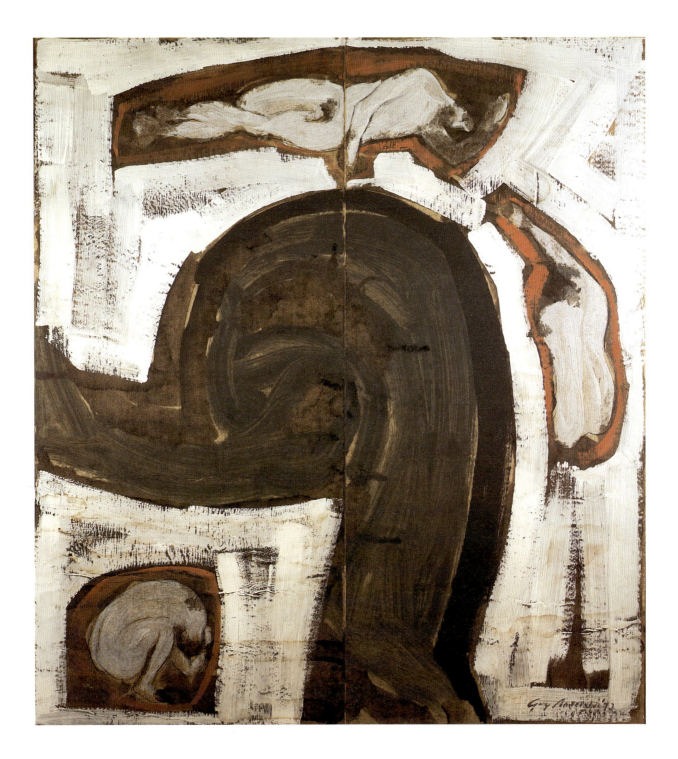

42. *Flight: Three Positions III*, 1972

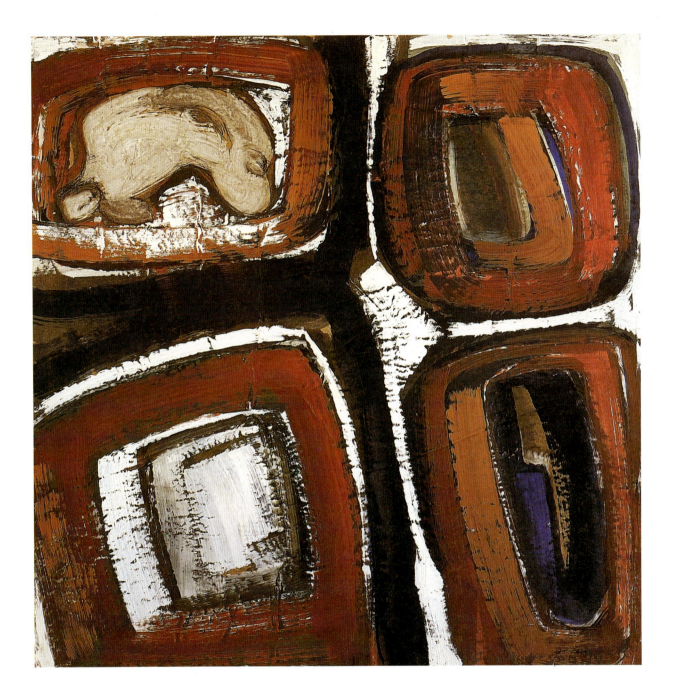

43. *Beirut, or Spring of Violence*, 1976

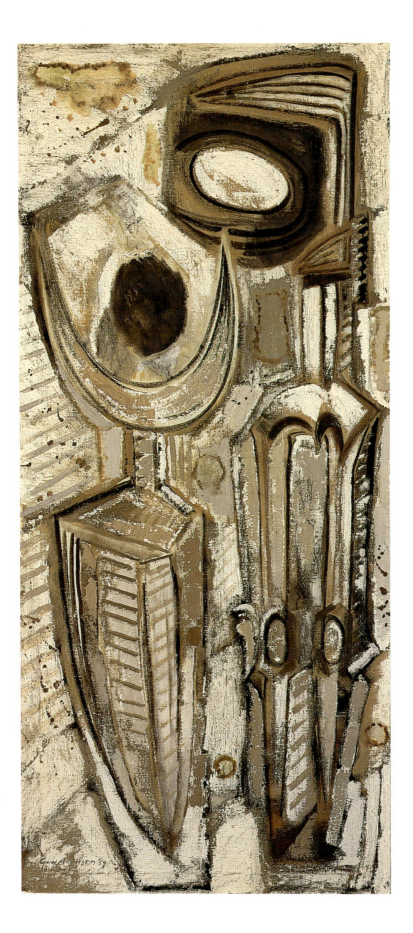

44. *Iron Flower*, 1959

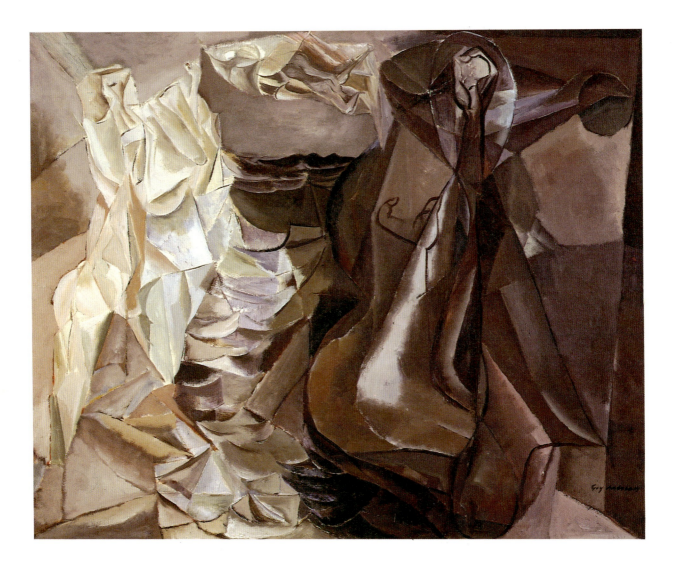

45. *Quick Cycle*, 1945

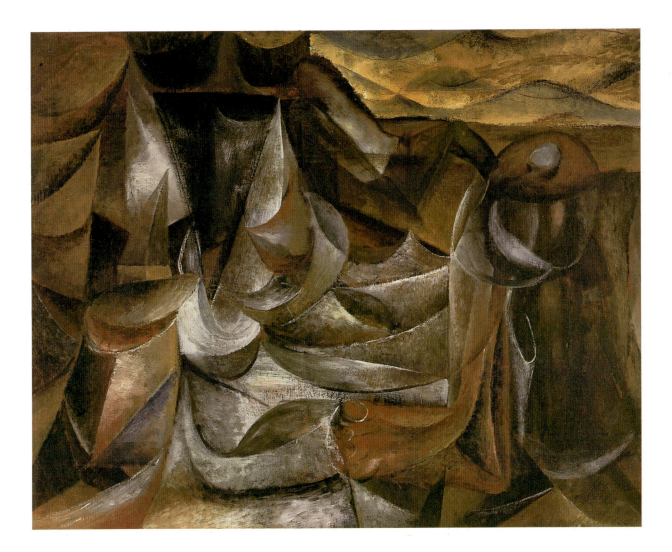

46. *Sharp Sea*, c. 1943

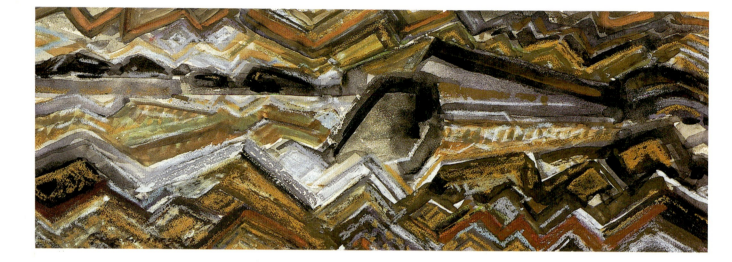

47. *Storm through the Channel*, 1958

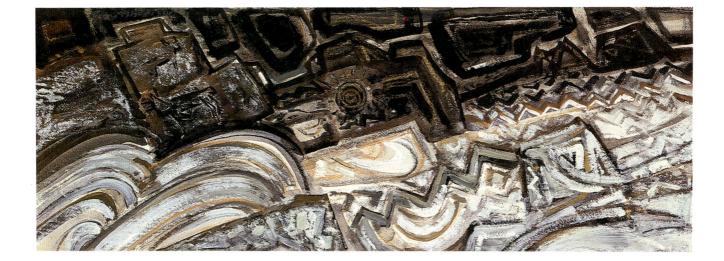

48. *Deception Pass through Indian Country*, 1959

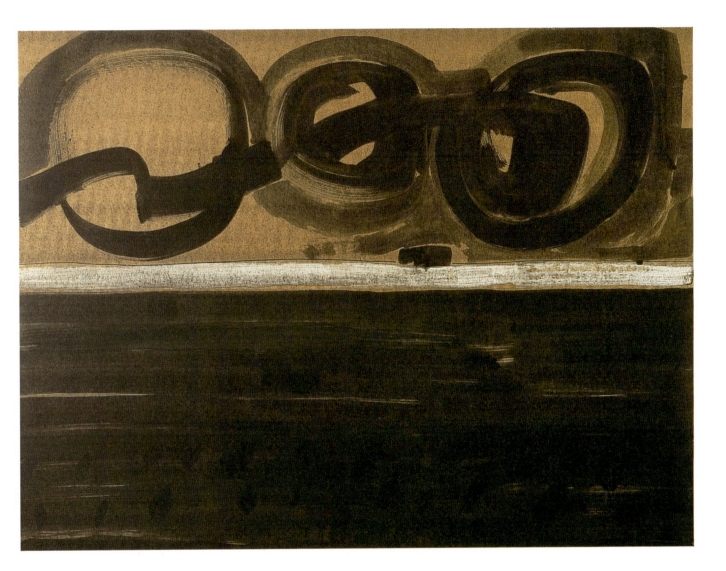

49. *Winter Landscape*, 1971

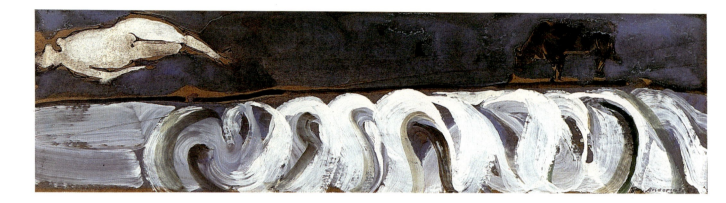

50. *Man, Bull and River, 1982*

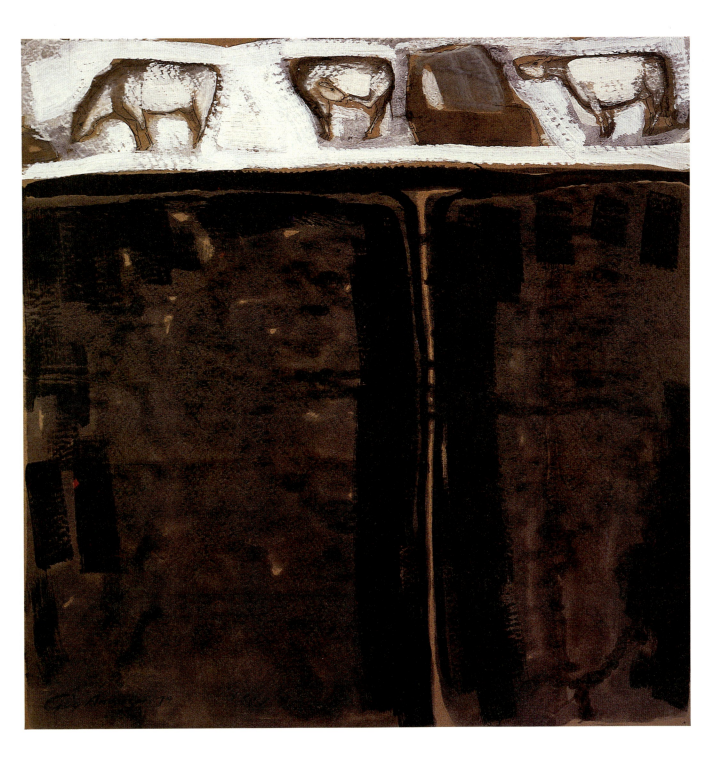

51. *Cows in the Snow*, 1974

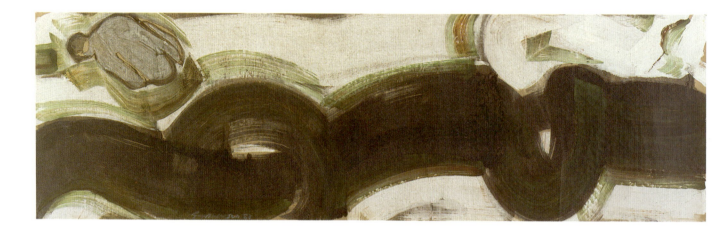

52. *Over a Dark Wave*, 1983

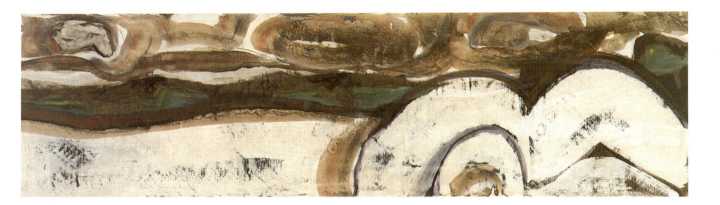

53. *Solo Flight over the Sea*, 1985

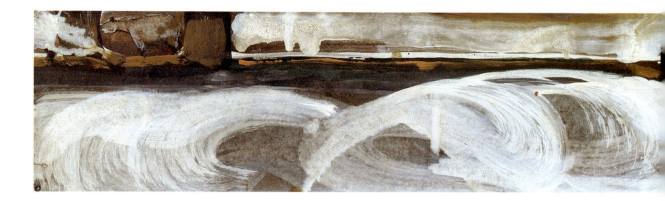

54. *Winter Sea*, 1979

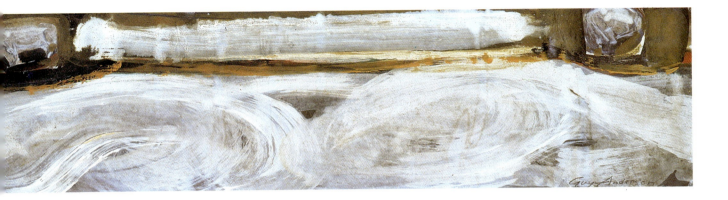

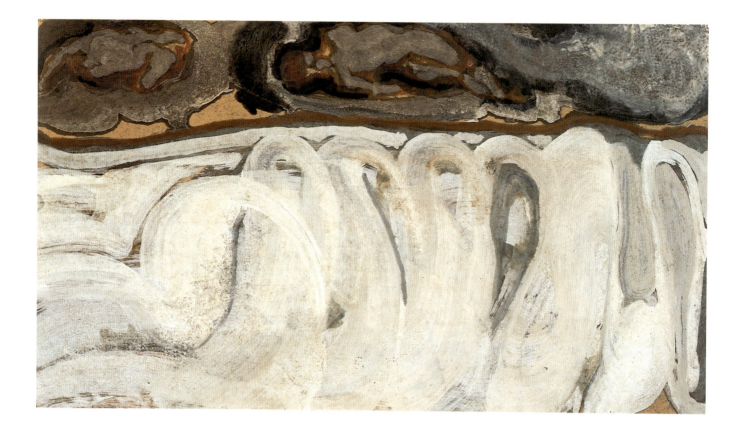

55. *Evening Sea*, 1984

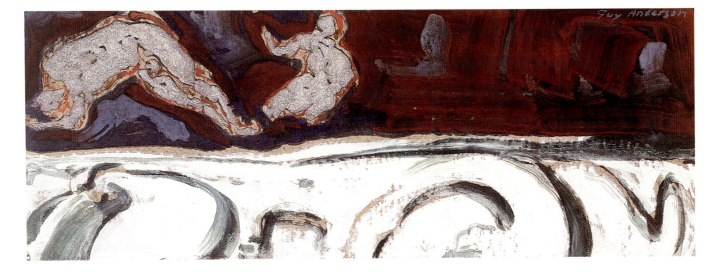

56. *Two Men Aloft and the Sea*, 1984

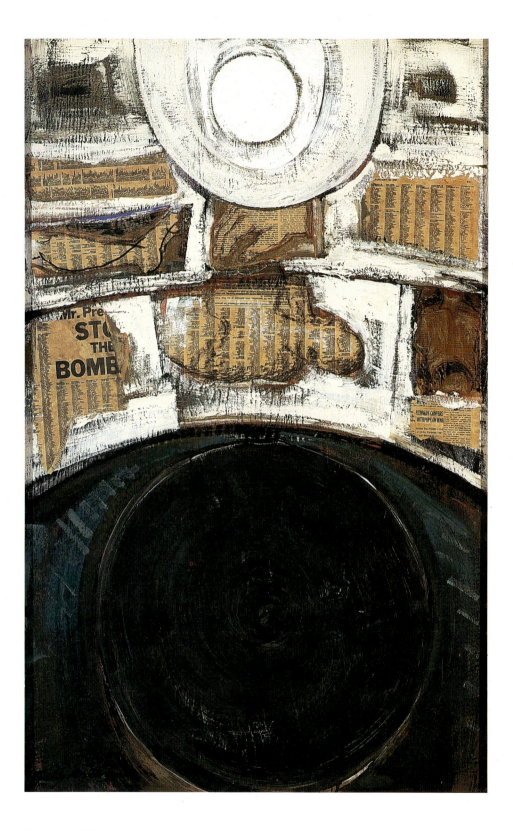

57. *Spring*, 1967

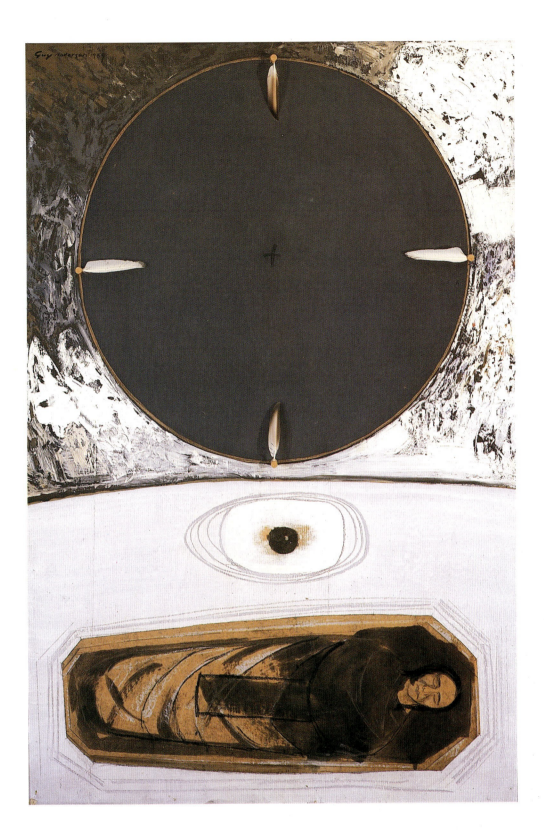

58. *Burial of a Northern Chief*, 1969

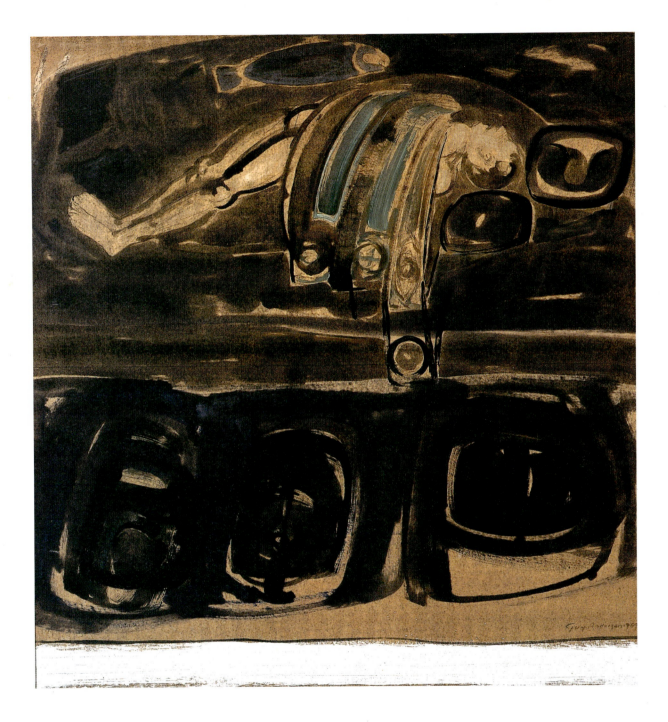

59. *Burial of the Son*, 1969

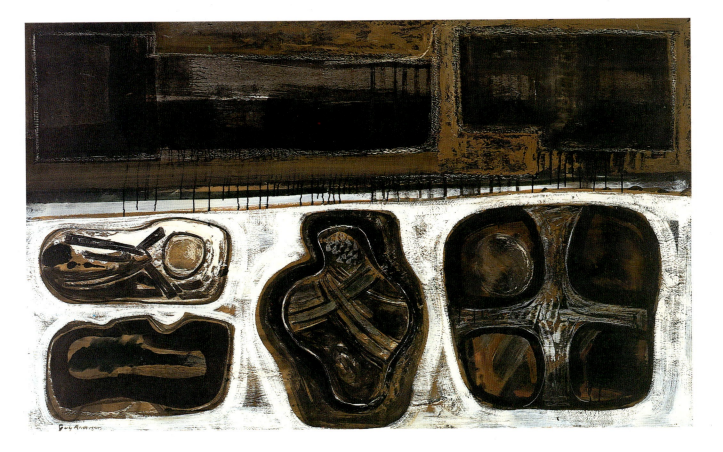

60. *Burial in Winter*, 1965

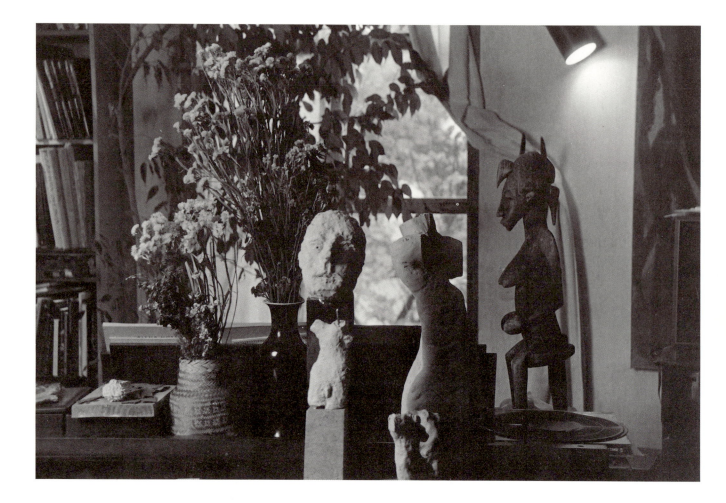

GUY ANDERSON

Guy Anderson's home and studio in LaConner, Washington, a tall, blue-gray, wooden structure, is punctuated on three sides by narrow, floor-to-ceiling windows. Their light, filtered by vines, illuminates a large single room that is both salon and bedroom. In the middle of the room sits Anderson's grand piano, its top an ever-shifting landscape of books and objects. The whitewashed walls are covered with large, recent paintings on paper; spaces between windows and doors and the sides of built-in bookcases are crammed with a rich melange of small studies, Asian scroll paintings, ethnic textiles, and found objects. Despite its visual and textural richness, the setting has a simple yet sophisticated quality that echoes the artist's spirited aestheticism.

A double flight of stairs outside, set against a steep hill adjacent to the house, leads to the artist's second-floor studio. The sweet, pungent smell of linseed oil and varnish permeates the room. Works in progress are pinned to sheets of plywood and lie on the floor along with covered pans of paint. Scattered about are stacks of drawings, bits of paper for collage, and rows of large, rolled paintings on paper. Stacks of books and magazines and slowly yellowing art reproductions are pinned up here and there to spark the artist's memory—a Renaissance saint, a Japanese ink drawing, a pre-Columbian sculpture. The studio, both the center and a microcosm of Anderson's world, bespeaks active engagement, not the slow abandonment of an elderly artist. Like Picasso, his lifelong hero, Anderson is producing major new works as he enters his ninth decade.

Guy Anderson was born November 20, 1906, in Edmonds, Washington, the only son of Irving Lodell Anderson and Edna Marie Bolduc. The young Anderson was exposed to music, drawing, and literature early on by his grandmothers and his father, who led a musical group and ran a small carpentry business. The politically independent Andersons (Irving was a socialist) fostered their three children's growth and independence by encouraging a wide range of experiences, including music lessons and excursions to the fledgling natural history museum at the University of Washington. Irving and Edna also instilled in their son and daughters an appreciation of the richness of the Northwest's natural environment. Guy was introduced to Asian art at an early age by his mother's friend, Mabel Thorpe Jones, who had a small collection of Japanese ukiyo-e Hanga prints, and by his piano teacher of six years, Anna V. Bassett. While living in Japan with her missionary husband, Bassett collected art and artifacts, which she kept in her studio-apartment in the Olympic Hotel in Edmonds. His teacher's deep feeling for the arts and the manner in which she lived left a lasting impression on the precocious Anderson. During high school, Anderson discovered the works of James Abbott McNeill Whistler and the great Spanish painters Velásquez and Goya, and subsequently painted a small group of Spanish-style family portraits of his mother, sisters, and aunts. Focusing his attention on the visual arts, Anderson committed himself to a lifetime of aesthetic search, and pursued professional art training with Eustace Ziegler in Seattle rather than attend college. Around this time, Anderson bought his first art book, *The Drawings of Michelangelo* (which he still has), a most prophetic choice given his lifelong commitment to figurative art.

A well-known and fashionable painter of Alaska and the Northwest, Eustace Paul Ziegler established a studio and school in the White Henry Stuart Building in downtown Seattle in 1925. Chief among the promising young artists the school attracted were Anderson and Kenneth Callahan. The Yale-trained Ziegler presented a professional program of study in life drawing, still life, portraiture, and painting in

nature, and provided his students access to his extensive library of art texts and color reproductions of the masters. Ziegler also frequently took his students to visit Charles and Emma Frye's collection and the Horace C. Henry Collection Gallery on Harvard Avenue, where they saw examples of the Barbizon and German schools of painting from the end of the nineteenth century. While under Ziegler's tutelage, Anderson began what would become a lifelong friendship with Kenneth Callahan and his wife, Margaret. The friendship became particularly important to both artists in the forties and fifties.

One of the artists who frequented the evening sessions in life drawing at the school was Ernest R. Norling, a well-known illustrator and artist of the period. Norling took an interest in Anderson's work and suggested he submit an application and portfolio to the Tiffany Foundation for a fellowship to study on the East Coast. Anderson was awarded a Tiffany Foundation Resident Scholarship in 1926, giving him his first opportunity to travel and see the original masterpieces he had known only in reproduction. Stopping in Chicago on his way to the Tiffany estate on Long Island, Anderson visited the Art Institute and saw its superb French impressionist works, which filled him with excitement and fresh insights. Given today's easier accessibility to national and international art, it is perhaps difficult to appreciate what the opportunity to paint during the week and spend weekends at the Metropolitan Museum of Art meant to a young artist from the West in the twenties; for Anderson it was a turning point. The residency also provided formal weekly critiques by well-known artists, such as Gifford Beal and Louis Comfort Tiffany, and helped to create a sense of community among aspiring artists from all over the United States. Spending most of his free time in New York reveling in the works of Rembrandt, Titian, Rubens, El Greco, and other old masters, Anderson often found it hard to return to landscape painting at the estate.

In 1927 Guy Anderson returned to Seattle eager to set up a studio and put into practice the lessons he had learned at the foundation and, perhaps more important, in the museums of New York and Chicago. Living with his family in Edmonds once again, Anderson used a small outbuilding for a studio. He began a period of rapid experimentation that took him from portraits done with the restricted palette of Rembrandt to pointillistic figure studies inspired by Georges Seurat's *La Grande Jatte*. Anderson established his own method of working during this period rather than a particular style. He limited his palette to a few colors plus black and white and left areas of the ground around objects exposed, practices that have remained consistent throughout his career. While working odd jobs to support himself, Anderson began to show paintings in local exhibitions, including those at the Fifth Avenue Gallery, one of the Northwest's early commercial galleries.

Anderson was included in an exhibit at the Fifth Avenue in 1929, and Morris Graves, impressed by the paintings, sought out Anderson in his Edmonds studio. Because of their mutual interest in the visual arts and their similar small-town backgrounds, Anderson and Graves, who was nineteen at the time, formed an intense friendship that contributed to their individual artistic development throughout the next decade. They often worked together and frequently shared the same studio, discussing concerns ranging from transcendentalism to the appropriate role of painting in contemporary society. Anderson's knowledge of art history complemented Graves's poetic spirituality and interest in Eastern art and religions. Their works from this period not surprisingly bear more than a passing similarity. The slablike paint application, exposed ground, and rough burlap support of Graves's *Moor Swan*, 1933, and Anderson's *Still Life*, 1934 (fig. 1), (both in the Seattle Art Museum collection) are typical of the artistic exchange between them.

Figure 1. *Still Life*, c. 1934

Figure 2. *Cabin in the Woods*, 1935

Anderson and Graves spent much of 1934 and 1935 winding their way south through Oregon and California in a pickup truck that served as both studio and home. They explored the countryside, working and painting until they reached Los Angeles. Anderson traveled on alone to Texas and into northern Mexico. By late 1935 both artists had returned to the Northwest, where Anderson painted the view from his studio window, which looked across his parents' yard in Edmonds. This painting, *Cabin in the Woods*, 1935 (fig. 2), shows Anderson's typical limiting of color to brown and green, and a growing sophistication of composition. The central triangle of grass and the diagonals of the rooftops provide a lively counterpoint to the wavy parallel bands of the landscape at the top and the bottom of the painting. Already at this early date, the artist was beginning to reduce the landscape to bold gesture and use multiple brushstrokes that coalesce into the broad, singular strokes of color that characterize his mature work.

In 1933 a major shift in the Northwest art scene occurred when the Seattle Art Museum at Volunteer Park opened. Designed by Carl Gould, the museum housed the activities of the Art Institute of Seattle (formerly the Seattle Fine Arts Society) and the burgeoning collection of Asian art and artifacts of Dr. Richard Eugene Fuller and his mother, Margaret McTavish Fuller. From the museum's inception, Dr. Fuller, its first director and benefactor, made it a policy to exhibit and collect representative samples of art produced in the Northwest and to provide part-time employment for area artists. Guy Anderson worked sporadically for the museum until the mid-forties installing exhibitions and teaching children's art classes. He was first included in the *Annual Exhibition of Northwest Artists* in 1926 (then sponsored by the Seattle Fine Arts Society) and continued to participate often in the yearly show as the society grew into a permanent museum.

The Seattle Art Museum mounted a solo exhibition of Anderson's paintings in 1936, bringing his work widespread regional notice (subsequent shows were held in 1945, 1960, and 1977). During this peripatetic period he traveled frequently, moved his studio between Seattle and Edmonds, and became part of the fledgling Seattle art community, which included University of Washington artists Walter Isaacs, Ambrose and Viola Patterson, and George Tsutakawa and the emerging "downtown" artists Graves, Fay Chong, Kenneth Callahan, and Mark Tobey.

Like many artists during the Great Depression, Anderson found employment with the Works Progress Administration Federal Art Project, and in 1938 was sent with artist Vanessa Helder to teach at the Spokane Art Center. Directed by Carl Morris, and with a faculty drawn from across the nation, the center was considered one of the best in the country. Anderson was stimulated by its numerous creative voices. The center's relative isolation brought the artists closer together, encouraging an open exchange of ideas and technical information among the teachers at the art center and with the nearby Washington State University faculty, which included Worth Griffin, George Laisner, and Clyfford Still. This exchange led Anderson to experiment with abstraction and found-metal collage. Anderson and Hilda Grossman Morris were the only teachers experimenting with abstract art and encouraged their students to explore nonobjective idioms; the other faculty were primarily concerned with the regional landscape or vaguely surreal imagery. Anderson was very productive during his two relatively cloistered years at the art center. He left Spokane with the benefit of his friendship with the highly intellectual Carl and Hilda Morris, whose broad interests in art history and philosophy had opened many doors for the young Anderson. By this time, he had begun to work with cubist-based abstract imagery, which he would explore well into the fifties, although never fully abandoning the human figure as his central concern.

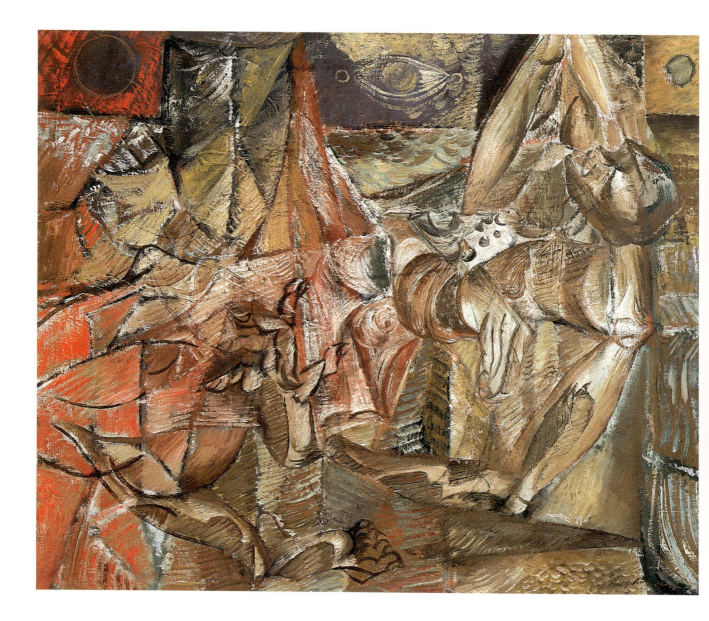

Figure 3. *Through Light, through Water*, 1940

The 1940 *Through Light, through Water* (fig. 3) is typical of the cubist-inspired work Anderson created after his return to Seattle. The large central figure is broken up into myriad planar fragments, which are simultaneously distinct from and a part of the landscape behind the figure. The fragmented dreamer floats somewhere between the sky and the water. Anderson evokes and maintains the figure by using specific anatomical reference—fingers, toes, joints—against abstract planes of modulated color. Astrological symbols along the top edge introduce a metaphysical implication that Anderson would later explore in a far more subtle form. The painting's limited palette, predominantly brown, green, and red, is representative of the artist's style, as is the paint handling, which ranges from translucent wash to heavily impasted pattern. Beyond certain anatomical references, Anderson uses very little drawn line in this work to describe or outline the form of the figure, which is broken into a rich succession of geometric planes. Although highly abstracted, the angular planes never completely abandon the description of human anatomy as would have happened in analytic cubism's more rigorous approach.

The forties were a seminal time for Anderson and the other artists who came to be identified as the Northwest school of painting—Tobey, Graves, Callahan, and, to a lesser degree, Carl and Hilda Morris, George Tsutakawa, and Margaret Tomkins. It was a period of marked intellectual growth and clarification of aesthetic issues among the artists. Tobey, Graves, Anderson, and Callahan were together in Seattle from 1940 to 1942, providing an opportunity for intensive social and intellectual contact. The group met in seminarlike sessions at Tobey's studio and at convivial social evenings at Margaret and Kenneth Callahan's for vigorous conversations on the role of art and the artist. They were all pacifists, and with the world careening into war, many discussions revolved around how to create art that would carry a powerful moral and spiritual message without reducing it to simple illustration. Various religious and philosophical systems were explored and debated; Tobey's Bahai beliefs encouraged the group's wide-ranging explorations of both Western and Eastern philosophies and religions. Because Kenneth Callahan was on the art museum staff and both Graves and Anderson worked there periodically, they had access to the Asian art treasures in the Fuller collection, which they often studied and discussed. Margaret Callahan's knowledge of modern poetry, drama, and music helped to further broaden the group's interests. The discussions of music led naturally enough to the role of timing and cadence in painting—from El Greco to the scrolls of Sōtatsu—which had a significant effect on the work of Tobey and Anderson.

Guy Anderson absorbed himself in a complicated and often contradictory search for a visual language that objectively expressed subjective experience. Centering his work on the human figure, Anderson projected his personality and experience through his imagery to the viewer, threading an added complexity into his paintings. In his struggle to come to terms with a multidimensional interpretation of reality, Anderson's painting moved from the highly abstract 1943 *Sharp Sea* (awarded the Margaret E. Fuller Purchase Prize in that year's *Annual Exhibition of Northwest Artists*), to the clear figure/ground composition of *Icarus*, 1949 (fig. 4). The artist began to assert the use of drawing, using heavy, emphatic outlines to define and break up images into geometric forms. Anderson pushed beyond the surface of the visible world, beyond "the simply retinal," as he has said, to expose those aspects of man and nature that lie deeper than appearance. Throughout his career, Anderson has worked to create a symbolic vocabulary to present most clearly his universal humanism. He expresses visually the poetry of his spiritual ideals, portraying the image of man and the landscape he loves.

The natural splendor of the Pacific Northwest greatly influenced Anderson and his compatriots. Frequent excursions into the mountains and along the shoreline for group picnics and sketching naturally led to discussions of the importance of a specific landscape to an artist's work and its power to evoke the spiritual. The sensuous appeal of these excursions in nature provided much inspiration for Anderson, Callahan, and Graves. Tobey, alone among them, preferred the more urban haunts of the Pike Place Market to the rigorous landscape of the Cascades. Not surprisingly, the artists sought out opportunities to live and work in closer proximity to untrammeled nature. Morris Graves first moved to LaConner in 1938, then to "The Rock" on Fidalgo Island, and in the forties was in and out of Seattle and Edmonds. Anderson visited Graves in LaConner, and during the summers shared a cabin with the Callahans near Granite Falls in the North Cascade mountains. He spent a great deal of time exploring the mountains and the shore. Anderson's affinity for the landscape has never lessened and has been the source of some of his most compelling works.

In 1953 Tobey, Graves, Callahan, and Anderson received national attention in a major article in *Life* magazine, "Mystic Painters of the Northwest," which ostensibly identified a unique school of regional painters. The article, which espoused the influence of the mist-shrouded landscape and the effect of Eastern philosophy on these artists on the distant western edge of the United States, gave little acknowledgment to their diversity or obvious connections to European modernism. Ironically, the increased notice of the group came as the social and intellectual cohesiveness that had been so beneficial to its members was dissipating, and the individual artists were going in other directions. Callahan went east to teach; Anderson moved back to Edmonds; Graves came back to Edmonds, then went on to Ireland and a period of travel, eventually settling in northern California. Tobey, feeling more isolated, even abandoned, spent more time traveling and in 1960 went to live permanently in Switzerland.

After teaching for a year at the Helen Bush School in Seattle, Anderson settled in the little fishing village of LaConner, at the mouth of the Skagit River. Renting a house at the edge of a field on Axel Jensen's farm in 1955, the painter slowly centered his activities and life in the small community. Surrounded by the wide, fertile fields of the Skagit Valley and crisscrossed by irrigation canals and a tidewater channel flowing into northern Puget Sound, the region's low, long, horizontal landscape rests under a broad, deep sky. Insisting at no small cost to his career to live without an automobile in the relative isolation of LaConner, Anderson freed himself of the pressures of fashion and the marketplace. The distance, both real and imagined, from the outside world permitted the artist the luxury of choice and gave him the appropriate time for conception and analysis of his work. His anthropocentric vision found its home in the rich, sweeping vistas of the Skagit Valley.

Anderson's artistic identity flourished as he established a daily routine of walks along the beach and painting in his studio. In paintings like *Island Country*, 1956 (fig. 5), and *Storm through the Channel*, 1958 he allows the brushstroke to assert its presence, its independence. No longer submerged in the modeling of form, the strong, rhythmic force of individual brushstrokes opens up the shapes, freeing the composition from the static, locked-in quality of his earlier works. The landscape has a fresh power and clarity in Anderson's work from this period; its cubist-inspired planes are loosely defined and in an agitated state of flux. It is as though the wind, which is so much a part of daily life in LaConner, were vibrating through the very core of existence.

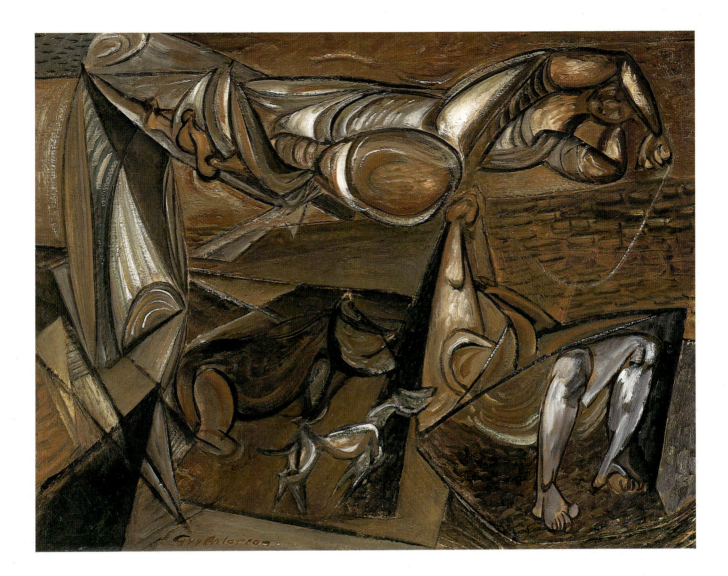

Figure 4. *Icarus*, 1949

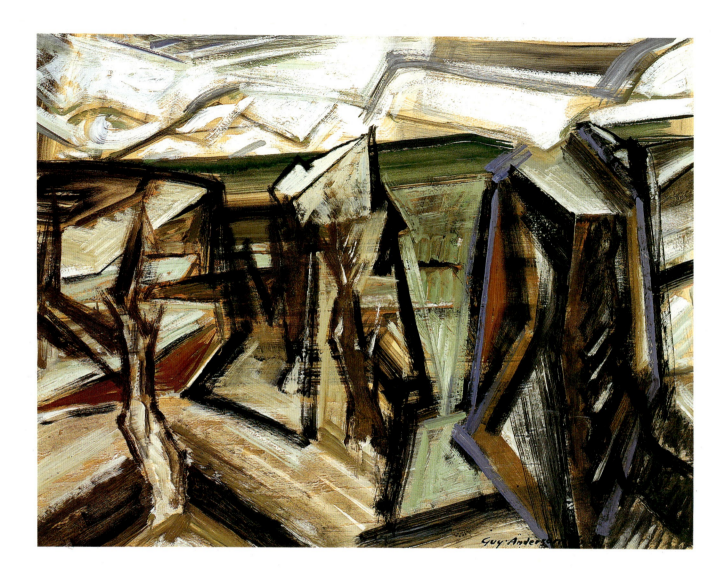

Figure 5. *Island Country*, 1956

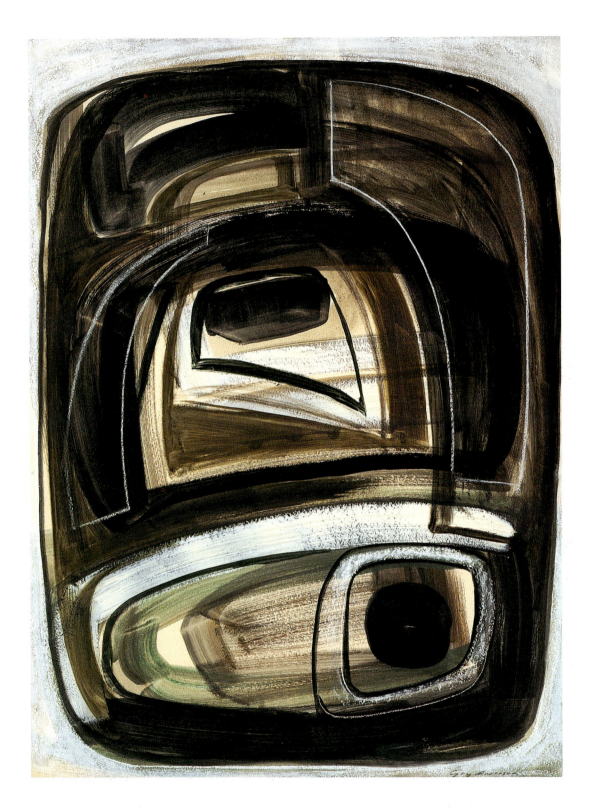

Figure 6. *Primitive Forms II*, 1962

Although long aware of and fascinated by the art of the Northwest Coast Indians, Anderson only began to use imagery directly inspired by it in the early sixties. His first contact with the art of the Haida, Tlingit, and Kwakiutl peoples was as a small boy visiting the natural history museum at the University of Washington, where he was fascinated by the image-within-an-image and story-telling aspects of the artworks. As an adult, he came to appreciate the sophisticated, geometric forms, with their oppositions of circles and squares, and the somber beauty of the weathered, organic colors. During the forties Anderson and Dr. Erna Gunther (and occasionally Tobey) visited the tribal longhouse outside LaConner on the Swinomish Reservation to witness the tribe's seasonal rituals and dances. These evenings in the smokey longhouse filled Anderson with awe of the power of symbolic ritual and reinforced his belief in the ultimate interconnectedness of all human mythologies. Anderson and Tobey followed the work of several native carvers, and often discussed the formal similarities they perceived in Northwest Coast designs and those found on Chinese bronzes from the Han and Shang dynasties. The all-over, dynamic patterning of Northwest Coast art, with its strong interplay of curvilinear within rectilinear forms, attracted Anderson, and he translated it into works such as *Primitive Forms II* of 1962 (fig. 6). The smaller forms contained within and by the larger rectangle with its rounded corners further echo their Northwest antecedents as does Anderson's choice of color. *Primitive Forms II* is one of his most literal translations of native American art. The work is also critical to understanding the compositional devices of Anderson's paintings in the seventies and eighties, which are characterized by narrative content and large geometric forms that often contain smaller human figures or activity within them. In these works Anderson captures the essence of Northwest Coast native art; by combining abstract pattern and symbolic narrative, he has created contemporary visual statements that embody a timeless humanitarianism.

Guy Anderson believes that painting can give expression to the deepest aspirations of the human spirit and has developed a distinctive way in which to communicate those aspirations. Alive with ancient rhythms, Anderson's paintings of the past two decades are the most cohesive and powerful works of his career. The artist has spent his creative life identifying and assimilating universal themes. His recent paintings represent a transformation of symbols from many sources—Christianity, Buddhism, pantheism, ancient civilizations, legends, superstitions—into a subjective language of form that is readily comprehended by the viewer. Using varying degrees of abstraction, Anderson has assembled a core of universal symbols, including the circle, a monist sphere with its associations of the womb/egg, cosmos, and void; the spiral as a symbol for creation and flow of energy; the ocean wave, which represents eternity and the eternal; a doughnutlike shape, the pi, which encompasses heaven and creation in much the same way as the Chinese yin and yang contain the two polarities of sexual union. Of particular importance to the artist is the *purusa*, or seed, which derives from the Brahmanic Hindu belief in the Mahāpurusa—the beginning—when the Cosmic Man was sacrificed and divided up for the creation of all things. The artist uses the seed as that which waits to become, the slumbering kernel of what will be. The *purusa* appears as the theme of an ongoing series of works and as a symbol within individual paintings, such as *Seed and Cosmos*, 1976 (fig. 7). A great white circle, like a mandala, anchors the painting; a seed lozenge centered above it splits two encapsulated figures that strain against the broad black and brown brushstrokes, holding them within the upper corners of the painting. Similar to his repetition of certain symbols, Anderson returns again and again to subjects, such as this Hindu belief, that attract him. He creates variation after variation until he feels he has exhausted its power to engage the viewer emotionally or

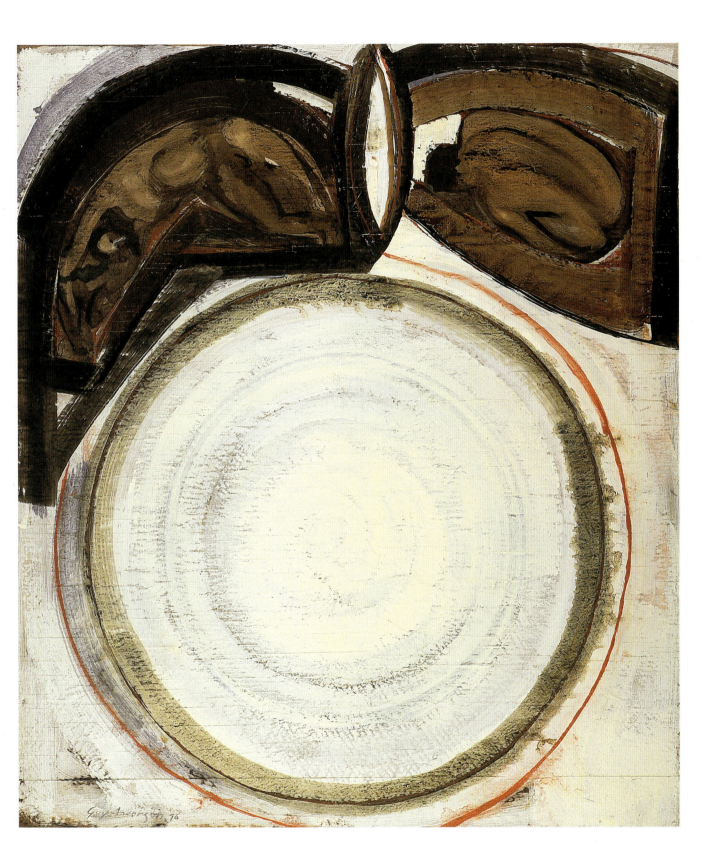

Figure 7. *Seed and Cosmos*, 1976

intellectually. These works stretch over time into lengthy, identifiable series, such as *Purusa*, *Mahomet*, *Elevation*, *Beach (*or *War*), *Dream*, *Icarus*, and *Daedulus*.

Anderson has on occasion given voice to highly personal feelings concerning specific political events, such as the Second World War, the civil rights struggle, the Vietnam War, and the bombings in Beirut. *Spring* is such a painting. In it Anderson uses as a collage element the "Stop the Bombing" advertisement that ran in newspapers nationally in 1967 to protest increased bombing of North Vietnam. It fills the spaces between the dark, blackish circle of the bottom half of the work and the bright, white sun disc at the top edge of the painting. The upper half of *Spring* is a compartmentalized field of body parts and lists of names from the ad, its staccato rhythm holding the richly painted lower half in balance. In this painting Anderson has moved from the specific protest of the newspaper page with its blaring headline to a more broadly drawn protest against the war in Vietnam and The Bomb by partially obscuring the headline itself. *Spring* is a most evocative and powerful statement of conscience in which a fragmented humanity drifts up from the dark night of the bombing to the luminous promise of the white sun.

With the heroic paintings of the last twenty years, Anderson has fused a universalized human image with the specific landscape of the Skagit Valley. Treating the timeless themes of birth, growth, and death with ever-increasing clarity, he has helped to redefine our expectations of painting in a decorative, superficial age. As a young man, Anderson made a commitment to figurative art, to an art that used the human figure symbolically and abstractly. Not content to create decorative figure studies or follow social realism, Guy Anderson has pushed the evolution of his figures to increasingly more abstract and compelling forms. Yet, Anderson maintains the authority of his figures and the veracity of their gestures by continuing to draw from life, whether a person on the street or a nude model in the studio. Beginning with the early Spanish-style family portraits, his work evolved from the cubist-inspired paintings of fishermen of the forties to the most abstracted notations of the "Everyperson" of the eighties.

Into the fifties, Anderson's figures seem most strongly influenced by the not-so-unlikely combination of El Greco, Picasso, and Orozco. Their forms had elongated, cylindrical volumes and a cubist solidity that was in contrast to their dramatic, cadenced positioning within the painting's composition. Since the late sixties, the figures have become more symbolically generalized and have a softer, more sensuous presence. In the ambitious paintings of the seventies and eighties, figures and symbols float against a shallow field—form emerges from the void. Anderson, celebrating mankind as harmonious traveler in the immensity of the universe, maintains a dynamic equilibrium between specific identification and abstraction. Male and female figures at times appear as stark, skeletal pictographs; at others, they express the fulsomeness of specific gender with a primal innocence. Aware as he is of the harmony of opposites embodied in the Chinese concept of yin and yang, or the Indian equivalent in the yoni and lingam, Anderson often joyfully depicts sexual fusion in a single work: self-contained beings locked in heroic encounters in a world free of time.

Anderson first used the reclining, or floating, figure in his paintings of the forties. Although tied into the overall structure of the cubist-inspired works by the fragmented, geometric planes of color, there is the suggestion of the eventual freeing of the figure from the ground. Since the seventies, the reclining figure often seems to float across the top of the painting, with the bottom of the composition opening into an immense lateral landscape (*Evening Sea*, 1984), or to stop abruptly against an opaque mandala

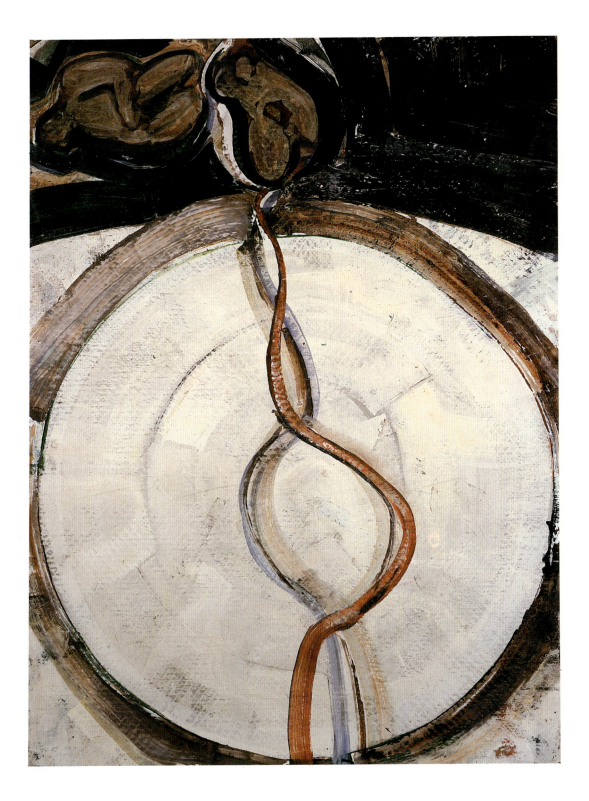

Figure 8. *Umbilical*, 1983

(*Umbilical*, 1983 [fig. 8]). In defying our sense of the physical world as we know it, the figure is interpretable as a dreamer or some otherworldly being, simultaneously existing separate from and within our gravity-determined reality. The figure's compression within a highly restricted space induces the giddy anticipation of the exhilaration of release. In a recent work, *Three Figures*, 1985 (fig. 9), the figures gain additional strength from the formal contrast of their supple roundness against the sharp angularity of the red forms that constrict and fill the space. Anderson's figures are instruments of great flexibility—from Greek heroes to sensuous love objects to somber corpses. Most recently Anderson has created a group of paintings (such as *White Forms Aegean*, 1983–84), in which multiple figures populate a broad, turbulent sky. The image balances on the polarity between birth and death and inspires both fear and hope. This image, like many in Anderson's oeuvre, transcends the tangible and reaches into the viewer's subconscious.

Unlike his contemporaries Tobey and Graves, Anderson never used water-based pigments like tempera or gouache, preferring the surface and feel of oil paint. But as it did for Tobey and Graves, the expressive possibility of line emerged as a central formal issue for the artist. Line in Anderson's work exists not so much as a single pull of charcoal or graphite stick, but as the track of a fully loaded six-inch brush across an eight-foot-long canvas. It is line as muscular energy. It is bristling, undulating, knotted, declarative. The individual brushstroke of the modeled forms of the forties has taken on a dynamic, expressive presence in the seventies and eighties. Anderson's use of line evolved from the occasional definition of an outline or the expression of a specific detail on a general field to become his primary tool in creating a work—from initial composition to finished painting. His line is calligraphically repetitive; strokes of the brush repeat themselves from work to work, and lines of a certain width and speed create the same circle in several works. Anderson's brushed line lifts the figures into existence with loving ease and defines the curves, spirals, and diagonals of his compositions.

As a lifetime student of music and the piano, Anderson understands that variations in pacing, sequence, and cadence can significantly change the impact of a painting. The issue of timing in painting was discussed frequently in the forties by Tobey, Graves, Callahan, and Anderson, with specific regard to the structure of space and objects in a painting and how their placement within a work altered and determined the points of stress. In Anderson's work, the linear brushstroke is the key to the rhythmic relationships between objects and, ultimately, the spiritual energy contained in the painting. The variability of Anderson's line is masterful. Even in his most measured paintings, the range of brushstroke is impressive and runs the gamut from reticent to spiky, lyric to dramatic.

Color has played a secondary role in Anderson's work over the past fifty years. The artist seems to prefer the subtle, monochromatic modulations of Japanese sumi painting to the chromatic explosions of German expressionism. Early in his career Anderson limited his palette to earth tones that rarely rise above chthonian values, allowing only bits of intense color. With much of his work nearly monochromic, color has a powerful impact when he uses it. The surface of Anderson's paintings, like their color, is carefully controlled and manipulated to underline the imagery and its metaphorical intention. He used oil on stretched canvas well into the sixties, but shifted to oil on heavy construction-grade kraft paper for the work of the past two decades. The surfaces of his elegant paintings vary from translucent stain through staccato scumbling to a full, rich impasto on top of the paper.

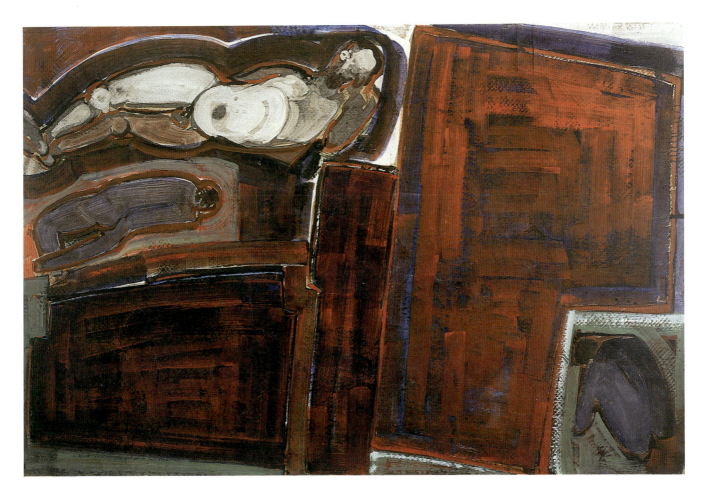

Figure 9. *Three Figures*, 1985

Possessed of an independent spirit and a vibrant mind, Anderson is repelled by the automation of technology and chooses to step out of the present to ground his paintings in nature and the timeless sources of world culture—from ancient Greece to Picasso, from Eastern philosophy to the art of Northwest Coast native peoples. Anderson believes the artist must learn from the history of art, assimilating and revitalizing that knowledge in his or her own environment, within him- or herself. Anderson has studied the worlds of philosophy, music, art history, and religion to create a hierarchy of symbols that correspond to his awareness and understanding of life. Perhaps the most powerful artist to emerge from the Northwest school, Guy Anderson is creating late in his career a body of work of great symbolic clarity and formal rigor. He investigates the seen and the unseen, translating the vitality of the direct experience of nature and life into art. Drawing on the strength of his identification with nature, Anderson searches the subjective realm for images that will communicate the diverse inner truths that can be gleaned from the Bhagavad-Gita or discovered during a walk along a stormy channel beach.

Bruce Guenther
Curator of Contemporary Art
Seattle Art Museum

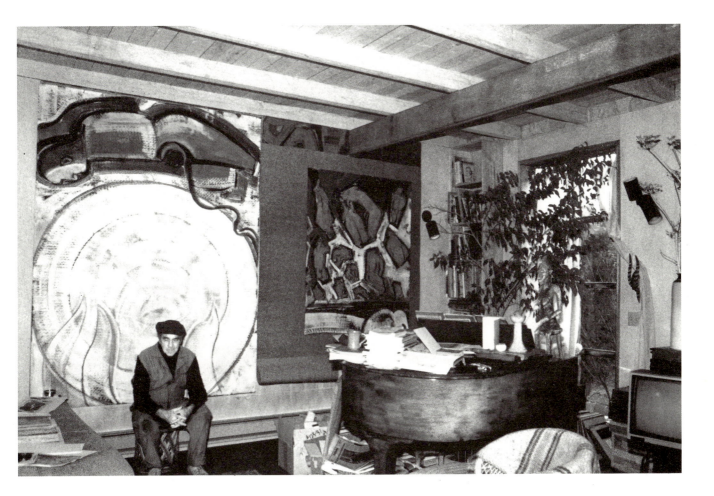

LIST OF ILLUSTRATIONS

Dimensions are given in inches; height precedes width.

11. *Birth of Adam*, 1969–70
Oil on paper
96 × 72
Collection of Robert M. Sarkis, Seattle

12. *Prometheus*, 1982
Oil on paper
96 × 72
Preston, Thorgrimson, Ellis and Holman, Seattle

13. *Seed in the Stream*, 1979
Oil on paper
48½ × 36½
Seafirst Bank, Seattle

14. *Egg and Moon*, 1980
Oil on paper
96 × 60
Collection of Raymond and Wendy Cairncross,
Seattle

15. *The Heavy Decision*, 1986
Oil on paper
60 × 46¼
Courtesy of Francine Seders Gallery, Seattle

16. *Nightfall*, 1984
Oil on paper
60 × 46½
Collection of T. R. Welch, Woodinville,
Washington

17. *Persian Gulf*, 1984
Oil on paper
96 × 72
Courtesy of Francine Seders Gallery, Seattle

18. *Around the Center*, 1986
Oil on paper
72 × 46¼
Courtesy of Francine Seders Gallery, Seattle

19. *Torsos in a White Sea*, 1983
Oil on paper
96 × 72
Courtesy of Francine Seders Gallery, Seattle

20. *Sky Full of Torsos*, 1983
Oil on paper
60 × 48
Collection of Raymond and Wendy Cairncross,
Seattle

21. *Ascent and Fall in the Morning*, 1986
Oil on paper
96 × 72
Courtesy of Francine Seders Gallery, Seattle

22. *Day Fragments*, 1985
Oil on paper
48 × 32
Courtesy of Francine Seders Gallery, Seattle

23. *Summer Swimmer*, 1985
Oil on paper
96 × 72
Courtesy of Francine Seders Gallery, Seattle

24. *Reading in the Rocks*, 1985
Oil on paper
96 × 72
Courtesy of Francine Seders Gallery, Seattle

25. *Untitled*, 1985
Oil on paper
72 × 32
Courtesy of Francine Seders Gallery, Seattle

26. *Untitled*, 1985
Oil on paper
72 × 32
Courtesy of Francine Seders Gallery, Seattle

27. *Swimmers Resting*, 1983
Oil on paper
96 × 72
Courtesy of Francine Seders Gallery, Seattle

28. *Reading Out of Doors*, 1984
Oil on paper
72 × 48
Courtesy of Francine Seders Gallery, Seattle

29. *Standing Figure*, 1984
Ink, wash on paper
12¹/₁₆ × 9⅛
Collection of the artist

30. *Floating Figure*, 1984
Ink, wash on paper
9¹/₁₆ × 12¹/₁₆
Collection of the artist

31. *Galileo's Dream*, 1982
Oil on paper
96 × 72
Courtesy of Francine Seders Gallery, Seattle

32. *Father and Son*, 1974
Oil on paper
108 × 96
Courtesy of Francine Seders Gallery, Seattle

33. *Prometheus*, 1950
Oil on canvas
30⅛ × 34
Collection of Mr. and Mrs. Robert J. Massar,
New York

34. *Encounter with Kali*, 1975
Oil on paper
71⅝ × 78⅜
Whatcom Museum of History and Art, Bell-
ingham, Washington

35. *Figure over the Sea*, 1984–85
Oil on paper
96 × 72
Courtesy of Francine Seders Gallery, Seattle

36. *Laocoön*, 1978
Oil on paper
43¼ × 48
Collection of T. R. Welch, Woodinville,
Washington

37. *Persian Philosophers*, 1978
Oil on paper
44½ × 53
Collection of Francine Seders, Seattle

38. *Icarus*, 1985
Oil on paper
94 × 144
Courtesy of Francine Seders Gallery, Seattle

39. *Autumnal Equinox (Sisyphus)*, 1984
Oil on paper
94 × 144
Courtesy of Francine Seders Gallery, Seattle

40. *The Exacting Moment*, 1986
Oil on paper
96 × 72
Courtesy of Francine Seders Gallery, Seattle

41. *Persian Dilemma*, 1986
Oil on paper
96 × 72
Courtesy of Francine Seders Gallery, Seattle

42. *Flight: Three Positions III*, 1972
Oil on paper
88½ × 81¼
Courtesy of Francine Seders Gallery, Seattle

43. *Beirut, or Spring of Violence*, 1976
Oil on paper
60½ × 60½
Collection of Robert M. Sarkis, Seattle

44. *Iron Flower*, 1959
Oil on canvas
58¾ × 26¼
Collection of Mr. and Mrs. Robert J. Massar,
New York

45. *Quick Cycle*, 1945
Oil on canvas
36 × 44
Museum of Art, Washington State University,
Pullman

46. *Sharp Sea*, c. 1943
Oil on wood panel
30 × 38
Seattle Art Museum, Margaret E. Fuller Purchase
Prize

47. *Storm through the Channel*, 1958
Tempera, watercolor, crayon, ink on paper
7½ × 22⅛
Seattle Art Museum, Eugene Fuller Memorial
Collection

48. *Deception Pass through Indian Country*, 1959
Oil on board
11 × 30⅜
Seattle Art Museum, gift of the Sidney and Anne
Gerber Collection

49. *Winter Landscape*, 1971
Oil on paper
72¾ × 98
Courtesy of Francine Seders Gallery, Seattle

50. *Man, Bull and River*, 1982
Oil on paper
19 × 72
Private collection, Seattle

51. *Cows in the Snow*, 1974
Oil on paper
78 × 77
Collection of T. R. Welch, Woodinville,
Washington

52. *Over a Dark Wave*, 1983
Oil on paper
29⅛ × 96
Collection of John Franklin Koenig, Seattle

53. *Solo Flight over the Sea*, 1985
Oil on paper
21 × 79
Courtesy of Francine Seders Gallery, Seattle

54. *Winter Sea*, 1979
Oil on paper
8¼ × 44½
Collection of Francine Seders, Seattle

55. *Evening Sea*, 1984
Oil on paper
17 × 30
Courtesy of Francine Seders Gallery, Seattle

56. *Two Men Aloft and the Sea*, 1984
Oil on paper
17 × 46⅜
Collection of Mr. and Mrs. Sital P. Alim, Seattle

57. *Spring*, 1967
Newspaper collage, oil on paper
46½ × 30
Seattle Art Museum, purchased with funds from
the Pacific Northwest Arts Council and the
National Endowment for the Arts

58. *Burial of a Northern Chief*, 1969
Oil, metal, collage, feathers on wood
73 × 49¼
Collection of Francine Seders, Seattle

59. *Burial of the Son*, 1969
 Oil on paper
 72⅛ × 69¾
 Seattle Art Museum, gift of Anne Gould
 Hauberg and John H. Hauberg in honor of the
 museum's 50th year

60. *Burial in Winter*, 1965
 Oil on plywood
 48 × 80
 Collection of Robert M. Sarkis, Seattle

61. *Fiery Night*, 1985
 Oil on paper
 60 × 48
 Private collection, Seattle

62. *Winter Seed*, 1985
 Woodblock print on newsprint
 $8^3/_{16}$ × 8
 Collection of the artist

BIOGRAPHY

Born on November 20, 1906, in Edmonds,
Washington

Education

Edmonds High School
Private study with Eustace Ziegler, Seattle

Teaching Appointments

1938–39	Spokane Art Center, Federal Art Project
1954	Helen Bush School, Seattle
1957–59	Fidalgo Allied Arts, LaConner, Washington

Selected Awards and Grants

1926	Tiffany Foundation Residence Scholarship
1935	Katherine B. Baker Memorial Purchase Prize, Seattle Art Museum
1944	Margaret E. Fuller Purchase Prize, Seattle Art Museum
1951	First Prize, Walnut Creek Arts Festival, California
1952	Music and Art Foundation Award, Henry Art Gallery, University of Washington, Seattle
1964	First Prize, Anacortes Arts and Crafts Festival, Washington
1965	Award of Merit for Art in Architecture, American Institute of Architects, Seattle
1969	Governor's Award of Special Commendation, Washington
1975	Guggenheim Fellowship
1983	Governor's Arts Award, Washington

Selected Commissions

1961	Mural, Hilton Inn, Seattle-Tacoma International Airport
1962	*Cultural Fragments*, Seattle Center Opera House
1970	Stone inlay, Seattle-First National Bank Building
1974	*A Day in the Legend of the Great Whale*, Bank of California Building, Seattle
1977	*Between Night and Morning*, Skagit County Courthouse, Mt. Vernon, Washington
1979	*Secret Pasture*, Washington Mutual Savings Bank, Seattle
1981	*Magical Egg in Space*, Bothell Public Library, Washington

Selected Public Collections

Art Gallery of Greater Victoria, British Columbia
Boymans-Van Beuningen Museum, Rotterdam, The Netherlands
The Brooklyn Museum
City of Seattle Collection
Henry Art Gallery, University of Washington, Seattle
King County Collection, 1% for Art Program, Seattle
Long Beach Museum of Art, California
Municipal Gallery of Modern Art, Dublin, Ireland
Munson-Williams-Proctor Institute, Utica, New York
Museum of Art, University of Oregon, Eugene
Museum of Art, Washington State University, Pullman
National Collection of Fine Arts, Smithsonian Institution, Washington, D.C.
Santa Barbara Museum of Art, California
Seattle Art Museum
Seattle Public Library
Tacoma Art Museum
Utah Museum of Fine Arts, Salt Lake City
Whatcom Museum of History and Art, Bellingham, Washington
Wichita Art Museum, Kansas

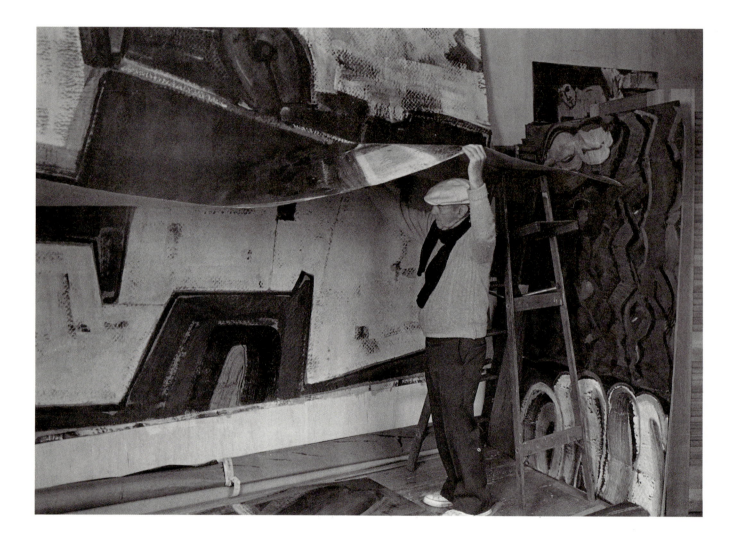

EXHIBITION HISTORY

Selected Solo Exhibitions

1936 Seattle Art Museum (also 1945, 1960, 1977)

1952 Zoe Dusanne Gallery, Seattle

1954 College of Puget Sound, Tacoma
Guy Anderson: Paintings and Drawings, Otto Seligman Gallery, Seattle

1957 *Guy Anderson: Paintings and Drawings*, Otto Seligman Gallery, Seattle

1959 *Recent Paintings and Drawings by Guy Anderson*, Otto Seligman Gallery, Seattle
Paintings by Guy Anderson, Emory Arms Art Studio, Everett, Washington

1960 *Guy Anderson*, Tacoma Art League Gallery

1962 *Oil Paintings by Guy Anderson*, Orr's Gallery, San Diego, California
Guy Anderson: Paintings, Smolin Gallery, New York
Michael Thomas Galleries, Beverly Hills, California

1963 *Recent Paintings and Drawings by Guy Anderson*, Otto Seligman Gallery, Seattle
The Kenmore Gallery, Philadelphia

1965 *Guy Anderson: Paintings and Drawings*, Otto Seligman Gallery, Seattle

1968 *Guy Irving Anderson: A Retrospective of Washes, Drawings and Oils*, Tacoma Art Museum

1970 *New Paintings by Guy Anderson*, Bon Marche National Gallery, Seattle
Recent Paintings by Guy Anderson, Francine Seders Gallery, Seattle

1971 *Guy Anderson: Recent Paintings*, Francine Seders Gallery, Seattle

1973 *Guy Anderson/Paintings*, Tacoma Art Museum
Recent Paintings of Guy Anderson, Francine Seders Gallery, Seattle

1974 *Guy Anderson '74*, Whatcom Museum of History and Art, Bellingham, Washington

1975 *Guy Anderson*, Francine Seders Gallery, Seattle

1977 *Guy Anderson: Paintings of the 1970s*, Seattle Art Museum
Guy Anderson: Works from 1942 to 1976, Henry Art Gallery, University of Washington, Seattle
Recent Paintings by Guy Anderson, Francine Seders Gallery, Seattle

1978 *Between Night and Morning: Studies for a Mural*, Francine Seders Gallery, Seattle

1979 *Guy Anderson—Paintings*, George Belcher Gallery, San Francisco
Works of the '70s, Francine Seders Gallery, Seattle

1980 *Guy Anderson*, Francine Seders Gallery, Seattle

1982 *Guy Anderson: Paintings*, Francine Seders Gallery, Seattle
Guy Anderson, Part Two: Mural Size Paintings, Francine Seders Gallery, Seattle

1984 *Guy Anderson: Paintings*, Francine Seders Gallery, Seattle

Selected Group Exhibitions

1926 *Annual Exhibition of Northwest Artists*, Seattle Fine Arts Society (also 1927) Fifth Avenue Gallery, Seattle

1928 *Annual Exhibition of Northwest Artists*, The Art Institute of Seattle (also 1929–32)

1929 Fifth Avenue Gallery, Seattle (also 1930)

1933 *Annual Exhibition of Northwest Artists*, Seattle Art Museum (also 1935–41, 1943–44, 1947, 1954, 1956–57, 1959–63, 1965, 1967, 1969)

1947 San Francisco Museum of Modern Art *Ten Painters of the Pacific Northwest*, Addison Gallery of American Art, Andover, Massachusetts (traveling exhibition)

1950 *Vincent Price Collects Drawings*, Oakland Art Museum Zoe Dusanne Gallery, Seattle (also 1951)

1951 Walnut Creek Art Festival, California

1952 *American Watercolors, Drawings, and Prints*, Metropolitan Museum of Art, New York

1953 *Four Pacific Northwest Painters*, Seattle Art Museum

1957 *Eight American Artists*, United States Information Agency (traveling exhibition) *Paintings and Drawings by Guy Anderson and Leon Applebaum*, Otto Seligman Gallery, Seattle

1958 *Morris Graves, Mark Tobey, Guy Anderson, and Jacob Elshin*, Woessner Gallery, Seattle

1959 *Paintings and Sculptures of the Pacific Northwest*, Portland Art Museum, Oregon

1961 *Northwest Painters, 1961*, Museum of Art, University of Oregon, Eugene

1962 Seattle World's Fair, Seattle Center

1963 *First Governor's Invitational Art Exhibition*, State Capitol Museum, Olympia, Washington (also 1969, 1981) Anacortes Arts and Crafts Festival, Washington (also 1964–65, 1975, 1981) *Northwest Art*, University of Puget Sound, Tacoma

1965 *Western States Regional Exhibition*, The Drawing Society of New York, San Francisco *Puget Sound Area Exhibition*, Charles and Emma Frye Art Museum, Seattle *The West Coast Oil Exhibition*, Charles and Emma Frye Art Museum, Seattle

1966 *A Showing of Northwest Artists*, Otto Seligman Gallery, Seattle *A University Collects: Oregon-Pacific Northwest Heritage*, Museum of Art, University of Oregon, Eugene (circulated by the American Federation of Arts 1967–68)

1967 *Northwest Artists' Group Show*, Otto Seligman Gallery, Seattle

1970 *Drawing Society National Exhibition* (circulated by the American Federation of Arts)

1971 *The Artist and the Sea*, Whatcom Museum of History and Art, Bellingham, Washington *Seventy-third Western Annual*, Denver Art Museum

1972 *Guy Anderson, Norman Lundin, B. Frank Moss*, Francine Seders Gallery, Seattle

1974 *Skagit Valley Artists*, Seattle Art Museum *Art of the Pacific Northwest*, National Collection of Fine Arts, Smithsonian Institution, Washington, D.C. (traveling exhibition)

1975 *Guy Anderson, Phillip McCracken*, Anacortes Arts and Crafts Festival, Washington *Northwest Masters*, Seattle Art Museum *Northwest Painters Invitational*, Museum of Art, Washington State University, Pullman

1976 *Artist Friends of Mark Tobey*, Francine Seders
 Gallery, Seattle
 Two Centuries of Art in Washington, State
 Capitol Museum, Olympia
 *Figurative Works: Guy Anderson, Norman
 Lundin, Laura Pizzuto, Leonard Schwartz,
 and Marsha Skolnik*, Francine Seders Gal-
 lery, Seattle

1977 *Northwest '77*, Seattle Art Museum
 Tribute to Zoe Dusanne, Seattle Art Museum

1978 *Guy Anderson and Kenneth Callahan*, Olin
 Gallery, Whitman College, Walla
 Walla, Washington
 Northwest Traditions, Seattle Art Museum

1980 *Contemporary Washington State Artists,* Cran-
 berry Gallery, Plymouth, Massachusetts
 West Coast: Art for the Vice President's House,
 San Francisco Museum of Modern Art

1981 *Portopia '81,* Kobe, Japan
 The Mind's Eye: Expressionism, Washington
 Year Exhibition, Henry Art Gallery,
 University of Washington, Seattle

1982 *Spiritualism in Northwest Art*, Henry Gallery,
 University of Washington, Seattle
 Pacific Northwest Artists and Japan, National
 Museum of Art, Osaka, Japan, and
 Seattle Art Museum

1984 *Northwest Art from Corporate Collections*,
 Waterfront Park, Pier 57, Seattle
 *The Spirit of the Northwest: Seven Contempo-
 rary Artists*, The John Pence Gallery, San
 Francisco
 Myth in Primitive and Contemporary Art,
 Francine Seders Gallery, Seattle

1985 *East/West/East*, The Public Art Space,
 Seattle Center House
 *Seattle Painting 1925–1985, Bumberbiennale
 1985*, Seattle Center

SELECTED BIBLIOGRAPHY

Books and Catalogues

Guenther, Bruce. *50 Northwest Artists*. San Francisco: Chronicle Books, 1983.

Guy Anderson. New York: Smolin Gallery, 1962.

Guy Anderson. Seattle: Seattle Art Museum, 1960.

Guy Anderson. Seattle: Seattle Art Museum and Henry Art Gallery, University of Washington, 1977.

Guy Anderson '74. Bellingham, Wash.: Whatcom Museum of History and Art, 1974.

Kingsbury, Martha. "Seattle and the Puget Sound." In *Art of the Pacific Northwest*. Washington, D.C.: Smithsonian Institution, National Collection of Fine Arts, 1974.

_____. *Northwest Traditions*. Seattle: Seattle Art Museum, 1978.

Koenig, John Franklin. "Ouverture sur le Pacifique." In *Informations et Documents*. Paris: U.S.I.S., American Cultural Services, 1972.

_____. *Northwest Art from Corporate Collections*. Seattle: Seattle Parks Centennial Commission, 1984.

Pacific Northwest Artists and Japan. Osaka, Japan: National Museum of Art, 1982.

Robbins, Tom. *Guy Anderson*. Seattle: Gear Works Press, 1965.

Skagit Valley Artists. Seattle: Seattle Art Museum, 1974.

A University Collects: Oregon Pacific Northwest Heritage. Eugene, Oreg.: Museum of Art, University of Oregon, 1966.

The Washington Year: A Contemporary View, 1980–1981. Seattle: Henry Art Gallery, University of Washington, 1982.

Periodicals

Albright, Thomas. "Anderson Exhibit—Art of the Northwest." *San Francisco Chronicle*, April 17, 1979.

Anderson, Guy. "Picasso Painting Reassures Artist." *Seattle Post-Intelligencer*, May 20, 1956.

_____. Untitled article on European trip. *Seligman Gallery Perspectives*, Winter–Spring 1967.

_____. "Wherein Does the Magic Reside?" *Seattle Post-Intelligencer*, April 23, 1967.

Appelo, Tim. "Cooling Off on Guy Anderson." *The Weekly* (Seattle), September 24, 1980.

"Artist Spends a Day at the Woodland Park Zoo." *Seattle Times*, July 25, 1954.

Benjamin, Max. "LaConner Art Colony Revolves Around Anderson." *Seattle Times*, March 14, 1965.

Berger, David. "Male Nudes Present a Special Problem." *Seattle Times*, November 28, 1984.

Callahan, Kenneth. "Mason, Applebaum, and Anderson Reflect Conviction, Sincerity." *Seattle Times*, February 17, 1957.

Callahan, Margaret. "N.W. Driftwood Becomes Sophisticated." *Seattle Times*, October 10, 1948.

Campbell, R. M. "Is it Guy Anderson's Turn to be 'Discovered?'." *Seattle Post-Intelligencer*, May 11, 1975.

_____. "Guy Anderson: Always Surprising, Always Pleasing." *Seattle Post-Intelligencer*, April 24, 1977.

_____. "Guy Anderson, the Artist Who Stayed Home." *Seattle Post-Intelligencer*, August 21, 1977.

_____. "Anderson Speaks Louder than Art's Young Turks." *Seattle Post-Intelligencer*, August 19, 1979.

_____. "Guy Anderson's Images are Unique." *Seattle Post-Intelligencer*, March 15, 1982.

Faber, Ann. "New Anderson Works at Seattle Art Museum." *Seattle Post-Intelligencer*, October 30, 1960.

————. "Guy Anderson Paintings Follow New Directions." *Seattle Post-Intelligencer*, March 17, 1965.

Glowen, Ron. "'70s Symbols on Display." *Everett Herald*, July 26, 1979.

Gonzales, Boyer. "Uniformly High Quality Marks U.S.I.A. Show at Museum." *Seattle Times*, January 20, 1957.

"Guy Anderson's Giant Works Line Rotunda Walls." *Bellingham Herald*, June 28, 1974.

"Guy Anderson's 'Magical Egg in Space' Dedicated at Bothell." *The Arts* (Seattle), January–February 1981.

"Guy Anderson's One-Man Show Overdue but Worth the Wait." *Seattle Post-Intelligencer*. July 11, 1954.

Guzzo, Louis R. "Callahan, Anderson to Take Art Shows to Europe, Far East." *Seattle Times*, January 9, 1957.

Hackett, Regina. "His Colors More Luminous." *Seattle Post-Intelligencer*, September 19, 1980.

————. "Paintings Good but Ignore the Label." *Seattle Post-Intelligencer*, July 21, 1982.

————. "His Oils Explore Ancient Myths." *Seattle Post-Intelligencer*, March 15, 1984.

Hayman, Sally. "The Good Brown Painters." *Seattle Post-Intelligencer*, August 11, 1968.

————. "Muted Color Makes Lyric Poetry." *Seattle Post-Intelligencer*, June 6, 1970.

Kangas, Matthew. "Guy Anderson's Double Retrospective." *Artweek*, August 27, 1977.

————. "Report from Seattle. Two Northwest Traditions." *Art in America*, September 1979.

Kelleher, Elise. "With the Artists." *Seattle Times*, September 22, 1952.

Lambert, Gordon. "Guy Anderson Paintings." *Artweek*, May 17, 1975.

Lee, Virginia. "An Interview with Guy Anderson." *Northwest Art News and Views*, June–July 1970.

Lehmann, Thelma. "Exhibit Personifies Philosophy Search." *Seattle Post-Intelligencer*, April 13, 1963.

Lunzer, Jean Hudson. "Painter is a Philosopher, Too." *Seattle Post-Intelligencer*, April 5, 1963.

McDonald, Robert. "The Relatedness of All Things." *Artweek*, April 28, 1979.

Miller, Stephanie. "Works of a Northwest Master Hang in Downtown Store." *Seattle Post-Intelligencer*, August 1, 1970.

————. "Two Northwest Artists United by Individuality." *Seattle Post-Intelligencer*, November 7, 1971.

Mills, Dale Douglas. "Pacific Northwest Living." *Seattle Times*, June 18, 1978.

Morgan, Lane. "The Seattle Selects Selection." *Argus* (Seattle), January 7, 1977.

"Mystic Painters of the Northwest." *Life*, September 28, 1953.

"Northwest Artist Featured at New York Gallery." *Seattle Times*, November 7, 1962.

"Northwest Art Shown in Mondale Home." *Seattle Times*, March 27, 1980.

Paynter, Susan. "KCTS: An Artful Insight to Three Artists." *Seattle Post-Intelligencer*, September 23, 1976.

Pierce, Helyn. "Guy Anderson—An Artist Apart." *Seattle Post-Intelligencer*, November 27, 1960.

Pumphrey, Ruth. "Artist Finds His Space at Own Place." *Seattle Post-Intelligencer*, December 27, 1981.

Robbins, Tom. "A Mystic Look at Three Painters." *Seattle Times*, April 21, 1963.

————. "Artist Series Opens with Guy Anderson." *Seattle Times*, January 9, 1966.

"Seattle Artists' Work to Tour." *Seattle Times*, January 20, 1957.

Seldis, Henry J. "Regional Accent: Pacific Northwest." *Art in America*, January–February 1962.

_____. "Guy Anderson Work Reveals Maturity." *Los Angeles Times*, April 13, 1962.

"Show of Work by Guy Anderson, 'Northwest Mystic,' Opens Today." *Seattle Times*, September 19, 1980.

Stromberg, Rolf. "Portrait of the Artist with Ochre Highlights." *Seattle Post-Intelligencer*, January 20, 1966.

_____. "The Artist at Bay." *Seattle Post-Intelligencer*, January 30, 1966.

Tarzan, Deloris. "Big Show by Guy Anderson." *Seattle Times*, March 29, 1973.

_____. "A Northwest Classic Exhibits." *Seattle Times*, May 11, 1975.

_____. "Guy Anderson Paints the Cosmos." *Seattle Times*, April 24, 1977.

_____. "Museums Pay Homage to Great Guy." *Seattle Times*, July 24, 1977.

_____. "A Show of One Painting." *Seattle Times*, March 5, 1978.

_____. "Skagit Magic Feeds the Soul." *Seattle Times*, July 11, 1982.

_____. "Anderson's Paintings: Sky, Sea and Time." *Seattle Times*, March 9, 1984.

Todd, Anne G. "At Seligman's." *Seattle Times*, February 8, 1959.

_____. "Primitive Influences Art at Hilton Inn." *Seattle Times*, August 13, 1961.

Tsutakawa, Mayumi. "Anderson Continues His Rich, Dark Works." *Seattle Times*, August 7, 1979.

Voorhees, John. "Fuller Selecting Art for Touring Show." *Seattle Post-Intelligencer*, December 30, 1956.

_____. "Painter Makes Area Live." *Seattle Post-Intelligencer*, February 23, 1959.

_____. "Anderson Art at Seders Gallery." *Seattle Times*, May 21, 1970.

_____. Anderson's Paintings Merit a Second Look." *Seattle Times*, July 12, 1970.

_____. "Major Anderson Art at Seders." *Seattle Times*, March 1, 1971.

_____. "Guy Anderson Show is Outstanding One." *Seattle Times*, November 2, 1971.

_____. "New Anderson Art Shown at Seders." *Seattle Times*, May 12, 1972.

_____. " 'Three Artists,' About Art, is Art Itself." *Seattle Times*, September 19, 1976.

Wehr, Ardemis. "Guy Anderson." *University Bookstore Newsletter*, January 1978.

Winn, Steven. "Seeing through Guy Anderson's Mystic Screen." *The Weekly* (Seattle), June 29, 1977.

Winslow, Pete. "Eight-Artist Show at Art Museum." *Seattle Post-Intelligencer*, January 20, 1957.